# RETHINKING THE FORMS OF VISUAL EXPRESSION

Robert Sowers

# RETHINKING
# THE FORMS
# OF VISUAL
# EXPRESSION

THE UNIVERSITY
OF CALIFORNIA PRESS

Berkeley / Los Angeles / Oxford

University of California Press
Berkeley and Los Angeles, California
University of California Press, Ltd.
Oxford, England

Library of Congress Cataloging-in-Publication Data

Sowers, Robert.
    Rethinking the forms of visual expression / Robert Sowers.
       p.    cm.
    Bibliography: p.
    Includes index.
    ISBN 0-520-06632-4 (alk. paper)
    1. Visual perception.   2. Art—Psychology.   3. Composition (Art)
I. Title.
N7430.5.S69   1990
701'.15—dc20                            89-34898

Printed in the United States of America

1  2  3  4  5  6  7  8  9

The paper used in this publication meets the minimum requirements of
American National Standard for Information Sciences—Permanence of Paper
for Printed Library Materials, ANSI Z39.48-1984.  ⊗

*In fond memory of Max Bernd-Cohen,*
*first teacher, joyous companion, lifelong friend*

# CONTENTS

# INTRODUCTION

This book is about the relation between the visual arts, how we understand that relation, and how it affects our understanding of the visual arts themselves. My concern with this vast, fundamental, yet almost studiously neglected subject grows out of my own work as a stained-glass artist. I have practiced, studied, and written about that art long enough to know its expressive qualities and how they are achieved. In trying to define the singular expressive qualities of this art for others— even architects interested in incorporating stained-glass windows into their own buildings—I have found myself over and over again battling two deeply ingrained misconceptions. First, the luminosity of the great cathedral windows apparently bedazzles most viewers, who react as though that luminosity emanated physically from the glass itself. But in any window anywhere, with or without colored glass, luminosity is determined primarily by the difference between inside and outside light levels. The unpleasant glare at the end of a dark tunnel is the same phenomenon carried to an irritating extreme. Second, viewers almost invariably regard cathedral windows as great pictorial achievements. But in fact the pictorial element, remarkable as it is, must be deliberately *singled out*. Otherwise it is simply swallowed up in the windows' overall effect, much as the text of choral music gets swallowed up in its performance. And when we examine that overall effect—the thing that stops viewers in their tracks when they enter the Cathedral of Chartres—it turns out to result from a pervasive ornamental ordering that is almost as strictly determined by architectural considerations as the great tilework ensembles of Islam. Here, then, is an art form that plainly refuses to be classified as painting or architecture or ornament

pure and simple—which is to say, here is an art form of almost universal appeal that defies some of our most fundamental distinctions between the visual arts. And in so doing, it raises questions with implications for our received conception of the visual arts as a whole. For if that conception cannot accommodate an ancient art form whose bona fides are beyond dispute, how can it possibly deal with the most innovative mixed-media aspects of contemporary art?

We feel that we should be able to construe the visual arts as an intelligible whole, that our tortured patchwork conceptions of them are our own, not inherent in the arts themselves. What, then, are we wrongly taking for granted? My answer: that the visual arts are autonomous, archetypal entities that can be defined independent of one another in terms of their materials and techniques. Almost everything about this assumption is highly questionable. If we can say that the Parthenon is more "sculptural" than a Gothic cathedral or a Rodin more "pictorial" than a Brancusi—and we can, and know what we mean when we do—the differences between architecture, sculpture, and painting are far less clear-cut than we assume. And we cannot solve the problem by simply either accepting or ruling out all such boundary-defying qualities across the board: many would argue that the sculptural qualities of the Parthenon are one of its strengths and the pictorial qualities of a Rodin one of its weaknesses. Nor can such qualities be dismissed as mere metaphorical muzziness: the art of bas-relief, no matter how it is defined, remains a combination of pictorial and sculptural qualities.

Instead of treating painting, sculpture, and architecture as distinct, if not mutually exclusive, categories of physical artifacts, therefore, we shall treat the pictorial, the sculptural, and the architectural as the basic forms of visual *expression*. We can then begin by asking what each one readily and importantly does that the other two can be made to do only with difficulty, if at all. And instead of assuming that these basic forms of visual expression have to be defined in material and technical terms, we can define them by comparing and contrasting their unique expressive aptitudes with one another, within the realm of visual expression as a whole. To so define them, however provisionally, will be the task of part 1.

In part 2 we will put these fledgling conceptions of pictorial, sculptural, and architectural expression to work. We will see how they may

be employed to analyze the relation between architecture and what once could be called, without irony, its "allied arts." Among other things, we shall see how architecture employs the pictorial and sculptural arts to its own ends or itself becomes more or less pictorial or sculptural; and how painting and sculpture in their turn become more or less architectural or environmental—all without necessarily forfeiting their own integrity as valid forms of visual expression. In so doing we shall challenge the common assumption that any trafficking "between" the arts is debased by definition. At the same time, however, we shall also begin to see what actually does cause the process of mutual accommodation between the arts to break down, and this will enable us to challenge the even more fatuous assumption that "anything goes"—that the realm of visual expression is simply a free-form playpen for the unbridled ego.

If this program begins to sound overambitious for so short a book, let me hasten to say what this book does not attempt to do. It neither tries to offer a fully developed theory of the relation between the visual arts nor presumes to say anything new about the nature of visual expression per se, even though that phenomenon plays a crucial role in this study almost from the first page. It is a plea for a more considered approach to its subject—not an attempt to say the last word on it.

Finally, a note about illustrations. When fundamental distinctions and basic affinities between different forms of visual expression are at issue, it matters greatly whether examples are simply talked about—and the reader expected to call them to mind—or placed conveniently at hand to lend specific visual substance to the argument. Our recollections of even the most familiar works of art can subtly mislead us. Thus the process of illustrating this book—by which I mean not just the selection but the sequence, juxtaposition, and coordination of the illustrations with the text—has evolved as an inseparable part of the process of writing it.

•   •   •

Although the book contains a few illustrations and recalls a few points from my studies on stained glass, that art comes to the fore only in chapter 3, as a special test case. Earlier versions of some ideas developed in this book were first published in the following journals: "A Hypothesis about the West Front of Chartres," *Art Bulletin* (December

1982); "The Myth of Collaboration," *American Craft* (December 1983/January 1984); "A Theory of Primary Modalities in the Visual Arts," *Journal of Aesthetics and Art Criticism* (Spring 1984); and "Über die Malerei mit Licht," *Kirche und Kunst* (March 1985). Once again, I am indebted to Ludwig Schaffrath, Johannes Schreiter, and Jochem Poensgen for acquainting me with excellent contemporary stained glass in the Rhineland—far more than I was able to illustrate or acknowledge here; to Nat La Mar for his usual sage editorial advice; to the writers with whom I have found myself in most complete *dis*agreement—for challenging me to give form to my own ideas; and to Judi Jordan, for forcing me to take an occasional breath of fresh air. But my principal debt is to Rudolf Arnheim, who, among other things, recognized the more general implications of the modality theory when it was still for me mainly a tool for defining the art of stained glass; urged me to write my paper on that theory; and, finally, read the manuscript for the book and saw me through countless revisions of its most difficult parts—all with his unfailing ability to pluck substance from crude ore and call nonsense by its right name. Without this invaluable assistance there might well have been no book at all.

# ON THE REALM OF VISUAL EXPRESSION

To define the realm of visual expression we must first be clear about the difference between visual expression and the purely physical attributes of the work of art. If, as any painter will confirm, the first mark on a surface creates a spatial tension, that effect must be counted as a primary expressive phenomenon. By comparison, the familiar workaday distinction between two- and three-dimensional art forms has nothing to do with visual expression in general or spatial tension in particular; it is a purely physical distinction that can make complete good sense only to those who are mainly concerned with the art *object*—its construction, restoration, storage, classification, merchandising, or exhibition. To be sure, we can describe certain more or less explicitly spatial effects in a work of art as two- or three-dimensional, but when this characterization is treated as a generic distinction between basic forms of visual expression, it becomes positively mischievous. George Kubler, for example, tells us that "all visible art can be classed as envelopes, solids, and planes";[1] and so it can. But to what end? The last of these categories is so broad that it would not distinguish the Mona Lisa from an unprimed canvas; the second is so narrow that it would not accommodate a mobile by Calder; and the first would exclude both the theater in Epidauros and the Colosseum in Rome, long recognized as important architectural landmarks even though they do not "envelop" anything. To these distinctions, which he accepts at face value, Kubler would add the traditional distinctions between art and craft and fine

and applied arts. But again, to what end? For they are equally problematic when applied to Egyptian sculpture, Greek vase painting, and Peruvian textiles—to much, if not most, of the great art that falls outside our own postmedieval tradition. Truly fundamental distinctions need not be subtle, but they *are* supposed to be true without exception, to provide a stable and nonjudgmental conceptual framework within which more specialized distinctions can be made rationally accountable to one another.

Nor does Clement Greenberg, generally considered to be one of our most distinguished critics, fare better in his famous attempt to define Modernist painting. For Greenberg the essence of Modernism lay in its attempt to deduce the limits of any discipline from the inside. Just as philosophers had used logic to determine the limits of logic, he argued, so the most significant painters of our time were using painting to determine the elements peculiar to the art of painting. They did this by eliminating from it whatever "might conceivably be borrowed from or by the medium of any other art. . . . The enclosing shape of the support was a limiting condition . . . shared with the art of theater; color was a norm or means shared with sculpture as well as theater. . . . Three-dimensionality is the province of sculpture." Thus it was that "pictorial art criticized and defined itself under Modernism" by stressing what Greenberg called, with an imposing turn of phrase, "the ineluctable flatness of the support."[2] But if this phrase means anything at all, it means the flatness that distinguishes tabletops from billiard balls—the kind of flatness you can bump into in the dark. He was forced to back-pedal: "The flatness toward which Modernism orients itself can never be an utter flatness. . . . The first mark made on a surface destroys its virtual flatness, and the configurations of a Mondrian still suggest. . . . a strictly optical third dimension."[3] Exactly so.

But then how does this "optical" third dimension differ from the physical one? What makes it pictorial rather than sculptural? And why did Modernist painters not jettison color as well if it was not unique to painting? We are never told, because the question of any physical property or technical device really belonging to a particular art is an inflated pseudo-problem. Flatness means one thing in painting, another in sculpture, still another in architecture. The presence of color in a Rothko or a Newman is no more retrograde than its absence in a Sung

painting is Modernist. To compare the picture frame, without which the high development of easel painting as an art form is hard to imagine, with the enclosing shape of the proscenium arch, which is a late and expendable part of the stage, is to compare what is essential to one art form with what is incidental to another that is radically different in kind. If Greenberg was defining anything at all, it was the technological myth of Modernism with a capital M.[4]

In short, to impose commonsense physical, geometric, or utilitarian distinctions on the visual arts in general, as Kubler would have us do, results only in an ill-fitting, culturally parochial order. And parceling out a mélange of expressive and physical attributes to the different visual arts, as Greenberg apparently would have us do, is an exercise in futility. Which art would gain an exclusive franchise to use paint, plaster, or steel? Contour, color, or texture? Open or closed form? Implicit or explicit imagery? Instead of treating the elements of visual expression as though they were palpable physical "things," we must do the opposite: *we must translate all the commonsense physical ingredients of the art object into the terms of visual expression.* We must realize that each medium, each style, each technique—even each material employed by the artist—has its own visual attributes as well as its own distinctive characteristics of handling and, therefore, its own unique expressive aptitudes and limitations. "To be convinced of this," Henri Focillon once observed, "one need only to imagine any such impossibility as . . . a charcoal drawing copied in wash."[5] And it is up to individual artists to discover the particular vocabulary of such elements that will best enable them to say what they want to say with their art. Sidney Geist, himself a sculptor, describes one of the greatest sculptors of our century doing just that:

> Clay and plaster are amorphous in their original states; they are essentially painterly mediums, best suited to temperamental natures. At a given moment Brancusi feels the need to develop his thoughts within the confines, both physical and psychological, of a hard and resistant material. In stone and wood he can achieve the tight surfaces and sharp edges he seeks more easily than in clay, since hard materials are susceptible to minute correction and refinement in a way that clay is not. His mind is orderly and calculating, and the process echoes the strict formal and artistic limitations he sets himself. Besides, a work of clay is chancy, it might have happened, while a carving is clearly *made.*

"Direct carving," he says, "is the true path to sculpture." It is a process that is irreversible, pointed toward an end. Carving has a destiny, modeling only a history.[6]

To the literal minded all of this will seem unabashedly metaphorical, and so it is. Indeed, Nelson Goodman not only defines expression in general as the "exemplification of metaphorically possessed properties" but goes on to demolish all objections to the definition: "A building may express feelings it does not feel, ideas it cannot think or state, activities it cannot perform. That the ascription of certain properties to a building in such cases is metaphorical does not amount to its being literally false, for metaphorical truth is as distinct from metaphorical falsity as is literal truth from literal falsity. A Gothic cathedral that soars and sings does not equally droop and grumble. Although both descriptions are literally false, the former but not the latter is metaphorically true."[7] And it *is* metaphorically true because, as Rudolph Arnheim has thoroughly demonstrated, "all perceptual qualities have generality. We see redness, roundness, smallness, remoteness, swiftness, embodied in individual examples, but conveying a *kind* of experience, rather than a uniquely particular one. This is equally true for dynamics. We see compactness, striving, twisting, expanding, yielding—generalities again, but in this case not limited to what the eye sees. . . . Thus, *we define expression as modes of organic or inorganic behavior displayed in the dynamic appearance of perceptual objects or events.*"[8]

To understand how the elements of visual expression differ from those of the workaday world is thus to understand what they *do*,[9] whether in a specific work of art, a particular medium or style, or, more generally, in one of the basic forms of visual expression, to which we now turn.

# I  THE PRIMARY MODALITIES

Our first cue to the relation between the visual arts is the color circle. It enables us to describe a complicated color, like reddish orange with a faint greenish cast, with such remarkable ease that we take that ability almost for granted. Not only are we able to describe such colors, but in the process we automatically indicate how they are related to all other colors, because of course such mixtures simply combine the three primary colors, red, yellow, and blue, insofar as their properties as pure hues are concerned. Yet when we set out to find an actual sample of any primary—yellow, for example—the more the choice is narrowed down, the more each sample seems to be affected by the appearance of another. Given sample A, sample B seems greenish; given B, A takes on an orange cast. Beyond a certain point only our *conception* of a primary yellow remains clear and stable, and even that is finally negative. We conceive yellow as the color in which no red or blue is admixed. Similarly, we understand the basic color systems to contain every *conceivable* combination of the three primaries, whether technically producible or not—and almost certainly they are not. At the same time, however, such color systems are self-delimiting. They do not take into account the distinctions between brightness value or hue saturation, let alone the far more elusive qualities that make some colors seem warm or cool, chalky or translucent, soothing or shrill. All of this is familiar to the point of banality, thanks to the color circle; yet perhaps for that very reason no one seems to have explored its implications for our subject. Let us do so briefly.

First, we realize that the elements or qualities that finally distinguish painting, sculpture, and architecture from one another need not and almost certainly *cannot* be reduced to any specific physical terms. Just as one physical sample of a primary yellow is as genuine as any other insofar as either is indeed primary, so a work in one technical medium is as purely pictorial as a work in any other insofar as it does what only pictorial expression uniquely and invariably does as a mode of visual expression. Second, we realize that our conception of the visual arts could not and *need not* be complete. Just as the basic color theories provide a place for every conceivable combination of the three primaries, technically producible or not, so our theory of the visual arts would encompass every conceivable permutation of painting, sculpture, and architecture even though these are limitless, beyond *pre*conception. And finally, any theory of the visual arts based on the structure of the color circle would be equally self-delimiting. It would extend only as far as the permutations of the three basic modes of visual expression could take it. Thus it would almost certainly include anything from a Viking ship to the latest Christo, but it would draw the line, without prejudice, when confronted with any work in which the visual element, however spectacular, seemed governed by some other major order of expression, such as drama or the dance.[1] In short, it would be systematic and comprehensive within its own bounds and circumspect about overstepping them.

Here, then, we begin to see what we might reasonably expect an adequate conception of the visual arts to do and not do. The analogy with color relations can take us only so far; to determine how far, we must understand why the primary colors are considered primary: although none can be reduced to the terms of the other two, each is infinitely combinable with the others. Now suppose that we could say the same of the arts of painting, sculpture, and architecture, pointing to some commanding principle of visual organization and, correlated with it, some distinctive expressive aptitude or function. If we could, and I believe that we can, is there any good reason not to think of those core qualities as the three "primary modalities" of visual expression? But first let us attempt to elicit them.

We begin with what might be called the pictorial modality. What principle of visual organization does a nonobjective painting like Ma-

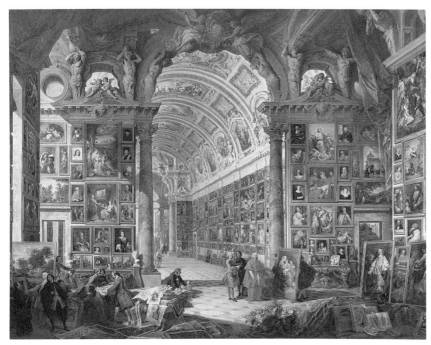

Figure 1.    Giovanni Paolo Panini, *The Gallery of Cardinal Valenti-Gonzaga*. 1749. Wadsworth Atheneum, Hartford.

levich's *White on White* have most in common with an overtly representational work like Breughel's *Procession to Calvary*? The answer has to be its radical self-containedness. Although any such work may affect or be affected by its immediate surroundings, it bears no intrinsic relation to them. Visually, in the starkest diagrammatic terms, it always moves inward two- or three-dimensionally—usually both. However much or little such a work may seek to re-present, in and of itself it is always a configuration whose internal ordering of lines, forms, colors, and tones is directly expressive—more or less resonant with the ordering of visual (or other) energies we have come to know elsewhere. This self-containment explains why it is possible to hang easel paintings almost cheek by jowl, as in Panini's documentary depictions of the great baroque collections (Fig. 1), in photographs of the official Salon exhibitions that rejected the work of the impressionists, and in the study galleries of some museums. Yet try to incorporate any such painting into its setting architecturally, and it rebels. Because of its radical introversion, its fluency, and its comparative lack of physical constraints, the

pictorial modality is almost ideally equipped to function as an instrument of pure *envisagement*.

The sculptural modality, by contrast, moves outward visually. In Susanne Langer's words, it "has a complement of empty space that it absolutely commands, that is given with it and only with it, and is, in fact, part of the sculptural volume."[2] To impinge on this space is to impinge almost tangibly on the work of art itself. To be persuaded of this effect, we need only imagine any sculpture grouped as tightly as the paintings in Cardinal Valenti-Gonzaga's picture gallery or, conversely, any painting, however bold, commanding the space that Easter Island figures command so effortlessly (Fig. 2). Because of its manifestly physical, psychologically compelling, and visually expansive "presence," the sculptural modality is uniquely well equipped to give tactual experience a concrete visual *embodiment*.

The architectural modality, in contrast to both the pictorial and sculptural, defines the locus of some human or humanly inspired activity, always from the inside and usually from the outside as well. Hence visually it combines inward- and outward-directed elements. To the extent that its interior expresses the activity it houses, it must "give way" to that activity—invite the vital expansiveness that activity presupposes. And to the extent that the activity enclosed requires outward expression, the architectural modality must become the outwardly expanding agent of that activity. In short, the architectural modality always presupposes some ideal or archetypal inhabitant—a family, an effigy, a corporate headquarters—and its use of enclosure and expansion as ordering principles is so distinctively its own that few would confuse the inside of the Statue of Liberty with a bona fide architectural space or the outside of Stonehenge with that of a huge walk-in sculpture. Both uses are elegantly illustrated in Rudolf Schwarz's schematic drawing of a Gothic cathedral (Fig. 3), and the unique function of the architectural modality is to give concrete visual embodiment to our modes of *habitation*.

Thus each primary modality can be distinguished from the others not only by its visual dynamics but by the expressive task it is best equipped to perform. Indeed, dynamics and expressiveness are finally inseparable. For as we shall see, when one form of visual expression apes another—imitates its obvious effects with no recognition of motivating dynamics—it can become labored, bombastic, pointlessly dif-

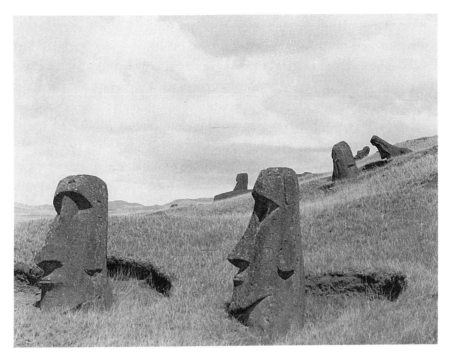

Figure 2. Monolithic sculpture, Easter Island.

Figure 3. Schematic drawing of a Gothic cathedral (after Rudolf Schwarz).

ficult, unreadable. Similarly, even the most rudimentary exercise of a primary modality may generate a genuine creation in that modality. Thus the covered wagons drawn into a circle against Indian attack in early cowboy movies of fond memory—a temporary (and for all I know completely fictional) expediency, to be sure, lacking any specific craft of its own—is a remarkably pure and striking product of the architectural *modality*, a distinct prearchitectural creation.

It remains to be shown that the primary modalities, like the primary colors, are infinitely combinable. As mixed-media experiments aggressively challenge many of the long-standing divisions between the arts, it would be easy to make a contemporary-sounding case for such combination. But the many ancient modes of visual expression are more impressive—because more widespread and highly developed and thus free from any self-conscious art-world posturing—as they combine the qualities of two or even three modalities. Bas-relief, for example, combines some qualities of both the pictorial and the sculptural modalities; mosaic (Fig. 4) and stained glass combine some qualities of the pictorial and architectural modalities; pre-Columbian and early Buddhist temples (Fig. 5) combine some qualities of the sculptural and architectural modalities. We find not only a number of unquestionably authentic "secondary" modalities, analogous to the secondary colors green, purple, and orange, but also a range of intermediate permutations in which a primary has largely assimilated or been assimilated by a secondary modality. Just as we can trace an unbroken sequence of colors from red to bluish red to purple to reddish blue to blue, so we might trace an almost equally unbroken sequence of artworks from a drawing to an incised drawing to a bas-relief and so on to fully emancipated sculpture-in-the-round—first in Egypt, then in Greece and the Far East, and then in medieval art.

Elsewhere, especially in baroque, rococo, and Islamic architecture, one can observe the authoritative combination of all three modalities in various ways. A particularly refined example is the dome of the Masjid-i-Shaykh Lutfullah in Isfahan (Fig. 6). This predominantly architectural form could hardly create its effect of utter completeness were it not also imbued, however subtly, with both the sculptural and pictorial modalities. From its teardrop point the dome curves downward, swelling and then turning under just before it meets the plain vertical cylin-

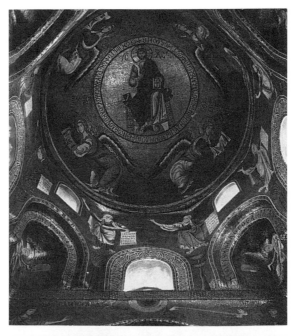

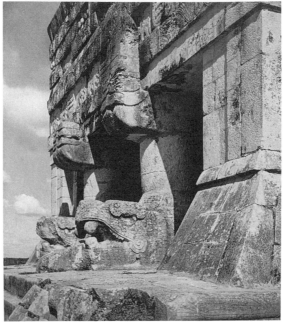

Figures 4 and 5.  Mosaics in the dome of the
Martorana, Palermo. Twelfth century (*top*); and
Temple of the Jaguars, Chichén Itzá. Maya-
Toltec period, about A.D. 1000.

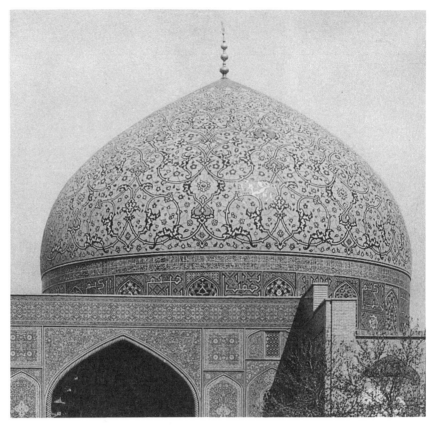

Figure 6.    Masjid-i-Shaykh Lutfullah, Isfahan. Seventeenth century.

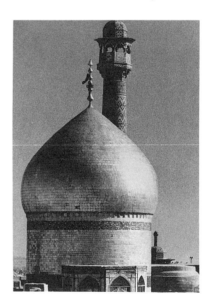

Figure 7.    Shrine of Hadrat-e Maju-
mek, Qum. Early sixteenth century.

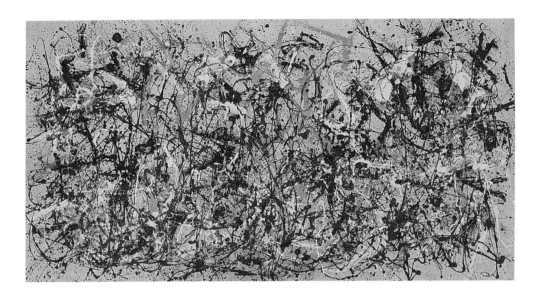

Figure 8.    Jackson Pollock, *Autumn Rhythm*. 1950. Metropolitan
Museum of Art, George A. Hearn Fund, 1957.

der of the lantern. Teardrop, flower bud, or whatever—the dome im-
plies sculptural expansiveness. Yet this effect is qualified by the surface
ornamentation. Indeed, were there no such ornamentation and were
the underturn increased even slightly, the sculptural expansiveness
would be noticeably increased, as it is in the dome of the Hadrat-e Ma-
jumek Shrine (Fig. 7). With its complex ornamentation, however, the
dome of the Masjid-i-Shaykh Lutfullah is thoroughly dematerialized,
its two apparently distinct planes of interlaced patterns hovering over a
field of yellow. The spatial illusion is not unlike that in Jackson Pol-
lock's *Autumn Rhythm* (Fig. 8).

Developments in a secondary modality may precede and influence
the development of art in a primary modality. Bas-relief in early dy-
nastic Egypt, for example, and again in Assyria (Fig. 9) achieved the
subtlest modeling of human and animal forms long before painting
achieved comparable effects. And painters who did finally set out to
achieve them found before their eyes the flat colors on those reliefs,
modulated by the effects of natural light and shade. What more likely
source of inspiration? In the Renaissance both the highly pictorial re-
liefs of Ghiberti's baptistry doors (Fig. 10) and the highly sculptural
paintings of Michelangelo (Fig. 11) give evidence of intensive inter-

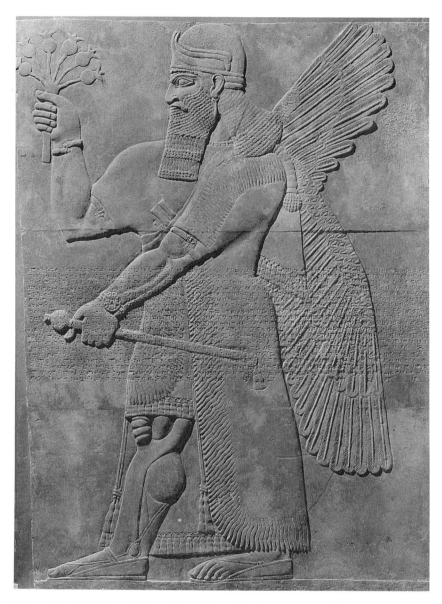

Figure 9.    Wall panel from the Palace of Ashur-nasir-apal II. Assyrian, ninth century B.C. Metropolitan Museum of Art, Gift of John D. Rockefeller, Jr., 1931.

changes between the two modalities—and offer proof that purity of mode has nothing directly to do with quality of expression.

These examples, drawn from a wide range of highly developed arts and cultures, take their place in the continuum or spectrum I am trying

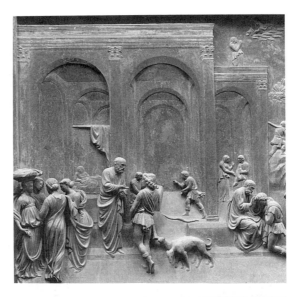

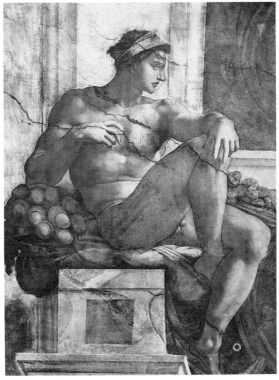

Figures 10 and 11.    Lorenzo Ghiberti, *The Story of Jacob and Esau*. Baptistry, Florence. About 1435 (*top*); and Michelangelo, nude over *Jeremiah*. Sistine ceiling, Rome. 1508–12.

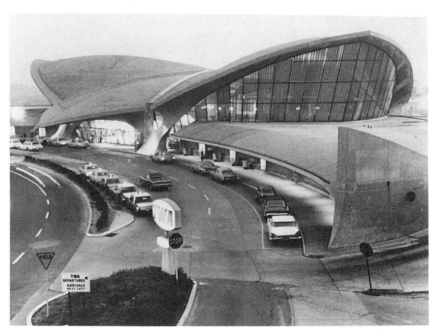

Figure 12.    Eero Saarinen, TWA Terminal, Kennedy International Airport, New York. 1956–62.

to establish. The primary modalities provide a conceptually stable and—so far as I can see—comprehensive framework within which all the actual or potential permutations of the visual arts can be compared and contrasted. But just as certain colors may seem inappropriate to their ostensible expressive purpose, so may certain borrowings between art forms—the external "aping" of effects to which I have already referred. No ill-conceived borrowing has been more conspicuously appalling in our own time than that of architects trying to emulate the bold sculptural form of the greatest monuments of the past—even the recent past. How do those efforts go wrong?

Of such efforts none was more ambitious than, or led to such peculiarly unsatisfactory results as, Eero Saarinen's TWA Terminal (Fig. 12), clearly inspired by Le Corbusier's chapel in Ronchamp (Fig. 13). Buildings like Saarinen's, Vincent Scully has observed, "give the impression of having been designed in the form of models for dramatic unveiling at board meetings and of never having been detailed beyond that point, so that, whatever their actual size, their scale reveals no connection with

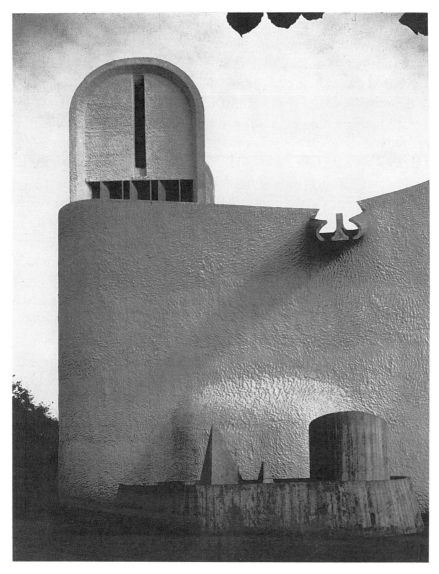

Figure 13.    Le Corbusier, Notre-Dame-du-Haut. Ronchamp. 1951–55.

human use and remains that of small objects grown frightfully large."[3] The criticism is valid as far as it goes; but as Scully would certainly agree, mere detailing as such may be little more than utilitarian excrescence. What we want to know is how detailing or anything else helps to create the impressive monumental effect in Ronchamp that is so clearly lacking in the airline terminal.

The west end of the chapel at Ronchamp is particularly informative.

There functional detailing is minimal, and Le Corbusier defines architectural status by other means. First, his wall, both vertical and monolithic (far more earthbound than Saarinen's sleek diagonal and partially glazed walls), bespeaks the possibility of enclosure; other elements of the west façade, in their various ways, define it. The rainspout, although highly sculptural in itself, dramatically expresses the function of draining water off a *roof*—a roof not visible at this end of the building. The bulge at ground level no less strongly expresses the function of containment, and in fact it houses the chapel's confessionals. And finally, there is the catch pool into which the water from the rainspout falls. In some ways this device is the most imaginative of all. In it the architect has placed three completely nonarchitectural geometric forms, approximately human in scale, that seem to communicate with one another within its protective enclosure; as surrogates for the chapel's users they convert the catch pool into a surrogate for the chapel itself. Thus at the very point where the structure of the chapel is least explicitly architectural Le Corbusier *illustrates* its architectural function, defining the catch pool as architecture by contrasting it with forms that are purely sculptural. In short, this great architect could do almost anything he wanted to do with sculptural form because he never allowed it to compromise the primary function of the architectural modality: to define a mode of habitation. Saarinen, like many of his colleagues, was led astray by what he took to be Le Corbusier's sculptural *liberties*. And his own incautiously "sculpturized" composition—which sometimes suggests a cyclopean birdlikeness and at other times seems a tour-de-force abstraction of streamlined forms that have little or nothing to do with the expeditious arrival and departure of airline passengers—exacted its revenge by de-monumentalizing his architecture. Saarinen strenuously disavowed the birdlikeness, but to no avail.

Even an outlandish combination of elements may make sense once we learn how to look beyond what it is, materially and technically, and ask ourselves what its elements do together expressively. A final example will illustrate the point. As long as we concentrate on Duchamp's notorious *Fountain* (Fig. 15) as nothing but a urinal "exactly like any other," further facts about it as such cannot help us understand why it commands attention: that the artist signed it "R. Mutt" and elsewhere employed the pseudonym "Rrose Selavy"; or that it was manu-

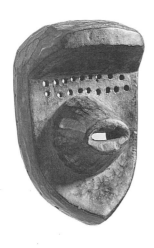 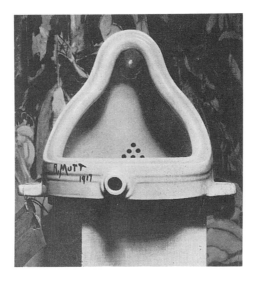

Figures 14 and 15.    Mask. Dan. Ivory Coast or Liberia. Private collection (*left*); and Marcel Duchamp, *Fountain*. 1917. Philadelphia Museum of Art, Arensburg Archives.

factured by "a company called Mott Works" and purchased "by Duchamp (himself!)"; or that he turned it on its back "like an immobilized turtle"; not even that an "anonymous defender of *Fountain* in the . . . fly-by-night journal *The Blind Man* . . . published by Duchamp himself, among others," had explained that "Mr. Mutt . . . took an ordinary article of life, placed it so that its useful significance disappeared under the new title and point of view—created a new thought for that object." No such information by itself can tell us *why* Arthur C. Danto should find this work "witty and daring and brash."[4] But once we ask what Duchamp made it do expressively, the problem begins to solve itself. Because he rotated the urinal a quarter turn, the flush connection, which normally would be at the top, becomes a rude mouthlike orifice at the bottom; and the drain perforations, now above that orifice, become a Picassoid constellation of eye-and-nostril elements. Given those features, the overall concavity of the urinal begins to echo a similar concavity in the African masks from which Picasso just ten years earlier had derived his first truly radical visual vocabulary (Fig. 14). In short, Duchamp's *Fountain* is the product of an astute visual maneuver that enables us to read it representationally, stylistically, and satirically in relation to its artistic milieu.

We might go on to see it also as an elegant reductio ad absurdum of the principle whereby a piece of newsprint "exactly like any other" could become an important element in a cubist collage. For it is Duchamp's positioning of the bogus artist's signature that authenticates the crucial quarter turn whereby his ordinary plumbing fixture, "exactly like any other," becomes the *work* of art. And if "Rrose Selavy" is a pun on "Eros, c'est la vie," can the signature "R. Mutt" on a urinal purchased from the "Mott Works" be taken at face value? In any case, our Mutt actually begins to seem "witty and daring and brash." Because the theory of primary modalities begins with the realm of visual expression as a whole in all its possible manifestations, it is not bound by what anything may do, or usually does, somewhere else. Instead we want to know what it does in the work under consideration.

We began this chapter by comparing the relation between the basic forms of visual expression with that between the primary colors. Because both are *three*-termed relations, both encompass all possible combinations of any two or all three of their respective elements—the colors red, yellow, and blue on the one hand and the pictorial, sculptural, and architectural forms of visual expression on the other. We know that the range of color combinations that can be created with the primary colors is vastly expanded when we add to it all the colors that are modified by either the tonal values from black to white or the degrees of hue saturation from pure color to the least perceptible tint—or both. We must now ask whether the realm of visual expression can be further structured by anything comparable to these two polar variables.

# II POLAR VARIABLES

*The Phenomenon of Scale*

Although scale has to do with physical size, it cannot be reduced either to that or to the relation between the size of a work of art and our own bodily size. The chapel in Ronchamp is truly monumental whereas the average commercial high rise that would tower over it manages only to be vaguely, if inadvertently, oppressive. Monumentality—or for that matter its opposite, the microcosmic form cultivated by Paul Klee—is a deliberate creation. But if scale is not determined by physical size, how does size enter into it? And how does scale interact with modality? Why do architects seem to be far more concerned with matters of scale than either painters or sculptors? How, in short, does magnitude function as an expressive variable?

Whatever we see has a particular magnitude with respect to our total field of vision at one extreme and our threshold of discrimination at the other. Between these extremes we normally can see and expect to see (1) commanding objects; (2) the basic disposition of their parts; (3) any pattern or patterns of features; (4) any distinctive textures; and (5) homogeneous tones or colors. These five visual gradations function together for us like a visual yardstick. Only the divisions in the yardstick are constant. How completely any object fills our field of vision at a given moment depends not only on its absolute size but also on its distance from us, which is highly variable. We seldom trouble to think, however, about the remarkable sequence of visual experiences we may

have simply by varying our distance from some large and commanding object of attention. As we approach such an object, things that initially were identifiable only as homogeneous tones or colors begin to reveal texture, textures begin to reveal elements of pattern, and so on. At the same time, however, part of what we saw initially expands and disappears beyond the limits of the visual field. In reality, of course, the process is always complicated by head movements, eye movements, and, not least, the scope of our visual interests and expectations. For now it will suffice to consider only interests and expectations. Let us then imagine a small group of reasonably observant viewers approaching the Cathedral of Chartres.

At first sight the cathedral is little more than an arresting silhouette on the horizon (Fig. 16). Only with difficulty can the viewers make out even the basic disposition of its parts. But almost automatically they attempt to do so, for as psychologists have established, seeing is a process of actively organizing visual stimuli into the simplest configurations the circumstances permit.[1] So true is this that our hypothetical viewers may discover apparent relations between major elements of the cathedral that they know are false or nonsensical or that seem to mimic compositional devices actually employed elsewhere. Particularly when the distant viewpoint is oblique to the cathedral's main axis, that structure will appear strangely metamorphosed. If viewed from the northeast, as in Figure 16, the transept may seem to have become the nave and the choir its transept, and the northwest tower may seem to have migrated to the end of the new pseudo-nave to become the dominant feature of the façade, like the tower of the Cathedral of Freiburg. If approached from the southeast, as in Figure 17, that same northwest tower may appear to have affixed itself to the south transept. Normally, we gloss over such nonsense configurations because we expect things to become clearer as we proceed. And they do. But sometimes disorder keeps pace with order, as in Figures 18 and 19. The first photograph (from which Fig. 17 was excerpted) shows the cathedral looming up over the horizon. Even though it does not yet fill the viewer's field of vision, it is the dominant element in the landscape. But just over the brow of the hill the cathedral is almost swallowed up by the inevitable trappings of gas-pump culture at the outskirts of the town. This is a dramatic but by no means unusual example of the con-

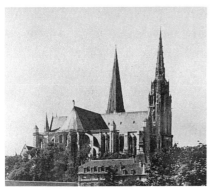
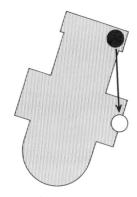

Figure 16.    Chartres from the northeast.

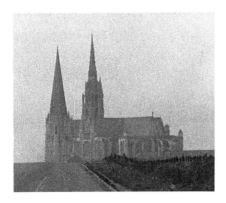

Figure 17.    Chartres from the southeast.

stant clash between foreground and background objects in our visual experience. If we simply turn a corner, the tallest building in the world may disappear behind a four-story loft building. This experience, so familiar that we take it for granted unless our attention is forcibly drawn to it, helps to explain why architectural forms can be far simpler than those of painting or sculpture without appearing to be simpleminded: all kinds of distortions and interferences are built into the experience of seeing them. Architecture houses art, but nothing houses architecture in a comparable way.

When our hypothetical viewers enter the cathedral square, they find themselves in what nearly everyone recognizes spontaneously as the optimum vantage point for viewing the west front (see Fig. 68). At this point all five orders of magnitude in the cathedral façade can best be perceived simultaneously. But the viewers here confront still another kind of disorder, this time of parts of the cathedral itself—the unresolved conflict between the two spires. This not only can be but has been interpreted in very different ways. The viewer who is a classicist by temperament, whose reality is laid out in Cartesian coordinates, reads it as a willful barbarism, an inexcusable affront to symmetry, axis, procession. The romanticist, whose reality is all process and striving in defiance of codified form, reads it as the final triumph over gravity of the spirit that had possessed the Gothic from the start. To the student of contemporary aesthetics, it perhaps reads as the syntactic prolixity of a major period style in its terminal phase. But as these viewers move still closer, that conflict, however interpreted, is displaced by another visual experience.

Figure 20 shows the center of the west front as it appears from a distance of thirty or forty feet. From there it so completely fills the viewers' field of vision that it reads as the limitless background for a whole subsystem of architectural detail now become legible, from ornamental moldings to corbel grotesques to powerful quasi-sculptural elements to a single major sculptural presence—the Christ figure in the central tympanum, whose regal gesture greets viewers and invites them to enter the cathedral.

At this point the sculpture displaces the architecture as the dominant focus of attention, quite as compellingly as if the figure were free-standing. Indeed, its effect is strikingly similar to that of the Kolbe in Mies van der Rohe's Barcelona Pavilion (Fig. 21), even though the Royal Portals of Chartres are almost invariably cited as a prime example of the integration of art and architecture, the Kolbe of their juxtaposition. This displacement or modulation has been analyzed most clearly by Susanne Langer. Sculpture stands for "the Self, or center of life," and architecture for

> the environment created by Selfhood. Each articulates one half of the life-symbol directly and the other by implication; whichever we start with, the other is its background. The temple housing the statue, or

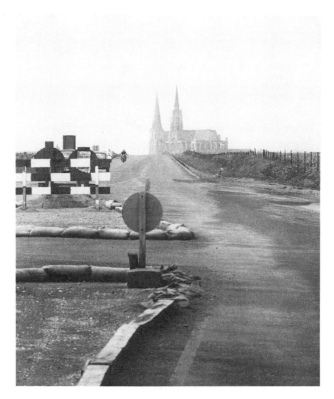

Figure 18.    Chartres from the Paris road.

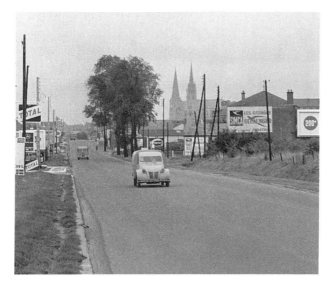

Figure 19.    Chartres from the edge of town.

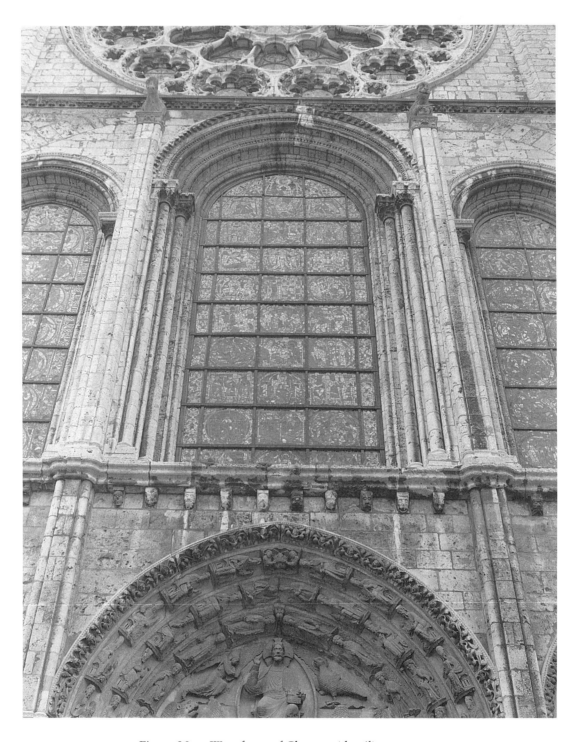

Figure 20.    West front of Chartres (detail).

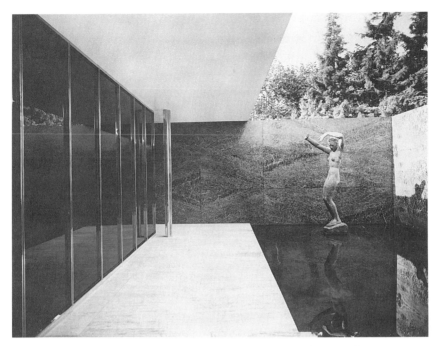

Figure 21.    Ludwig Mies van der Rohe, German Pavilion: sculpture court with nude by Georg Kolbe. Barcelona Exhibition, 1929. Photograph courtesy Mies Van der Rohe Archive, The Museum of Modern Art, New York.

conversely the statue housed in the temple, is the absolute Idea; like all absolutes, intellectually motionless, a matrix of artistic expression rather than a directing principle. . . . The great cathedrals give room to a wealth of statuary directly related to the architectural creation, *yet not creating architecture.* The cathedral is a place created for life symbols rather than actual life, which falls too far short of the architectural idea.[2]

Little wonder that the Barcelona Pavilion became almost a cult shrine to some of Mies's frontier acolytes. Yet this very quality—"the temple housing the statue . . . the statue housed in the temple"—is what most distinguishes his creation from all the desperate high-noon confrontations on windswept plazas that have followed in its wake.

But to return to our hypothetical viewers. By this time their attention has become so completely localized that they have forgotten the battle of the spires. Moving still closer, they may even become aware that the sculpture was carved, and could only have been carved, out of a much finer-grained stone than that of the cathedral itself (Fig. 22).

Indeed, the fabric of the cathedral may strike them as coarse by comparison. But if it does, they have accommodated themselves to still another shift in magnitude. For the cathedral stone can be considered coarse with respect only to the sculpture, not to the architecture of the cathedral as a whole. And should our viewers then oblige us by reflecting on this whole sequence of visual experiences, each flowing so simply out of its predecessor, they might well be astonished at the cumulative accommodations. For when the cathedral first came into view, it was little more than a marginally decipherable object on the horizon. Although it may have been the commanding object of visual attention, on our five-point yardstick of visual magnitudes it was close to the threshold of discrimination. The basic disposition of its parts could be made out only with difficulty and its elements of pattern and texture not at all. Not until the viewers entered the cathedral square were they able to perceive the distribution of parts, patterns, and textures in the west front itself more or less simultaneously. But by the end of the sequence, when they were comparing the textures of structural and sculptural stone, the west front had ballooned out beyond their field of vision and its principal parts nearly so, and its elements of pattern were only marginally discernible.

Although extreme, this example underlines my point: the larger any primary object of visual attention and the greater the *range* of distances from which it can be seen, the greater the shifting of elements from one magnitude to another as viewers approach or move away from it. Any increase in the power of discrimination afforded by moving closer is offset by a corresponding loss of context, and vice versa. If we accept this point, it becomes possible to define one of the indispensable attributes of a sense of scale: the ability to create forms legible *in all the magnitudes of order in which they are intended to be seen.*

Even more significant, we begin to realize why scale is normally of greater concern to architects than to artists, except when the relation between art and architecture is at issue. No matter how impressively stable the physical elements of a building may be, architecture as a visual environment is finally the arena of some envisaged activity—some mode of habitation. But except in the case of sepulchral architecture, habitation is an activity that presupposes mobility. Thus architecture normally begins by assuming, accommodating, and visually exploit-

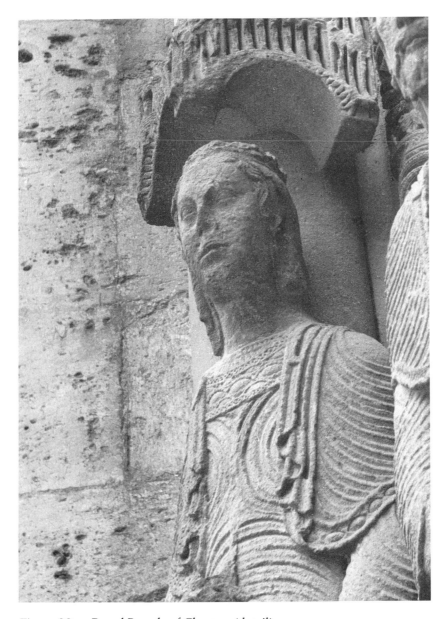

Figure 22.    Royal Portals of Chartres (detail).

ing the mobility of its ideal or archetypal inhabitant. Ultimately, the architectural creation is a continuum of spatial modulations that can be experienced only sequentially, from an indeterminate number of more or less clearly defined vantage points, near and far, inside and outside.

Self-contained paintings and sculpture, by contrast, demand to be viewed from specific and definable distances. Experiments have shown that truly comprehensive vision is limited to the area that can be scanned by eye movements unassisted by head movement and that paintings must be viewed from a distance that makes this scanning possible if each part of the image is to be seen directly in relation to the whole:

> H. Maertens has established that from a distance twice the length of a painting's longer dimension, the whole will be seen comfortably at an angle subtending about 27°. At such a distance and size, the range of the visual field includes the boundaries of the picture, so that any part fixated by the eyes is seen as located at its place in the whole. To a lesser degree other aspects, such as direction, shape, size, and color, will also be seen in the context of the total composition. It seems safe to assert that unless the total visual pattern is comprehended within this range, it cannot be seen and judged as an integrated whole.[3]

Similarly, sculpture demands to be seen from the circumference of positions that enable us to view it as a comprehensive whole.

It might seem that we have arrived at an impasse—that architecture makes demands that painting and sculpture cannot meet without compromising their integrity. Yet as we have already seen, pure architecture and pure sculpture do meet and are reconciled in such radically different situations as the façade of Chartres and the Barcelona Pavilion. It could be argued that in Chartres the problem is finessed, rather than actually solved, by exploiting the extreme difference between the size of the architecture and the sculpture. For as we have already seen, the ideal distance for viewing the entire west front is far too great for the sculpture to read as anything but pattern and texture. But the sculpture was so conceived that it *could* read that way very effectively—as an integral part of the architectural composition. The cathedral façade is designed, however, so that when viewers reach the point where the sculpture begins to command their attention, the façade can function as an effective setting or background for that sculpture. What we see here, in short, is a brilliantly orchestrated spatio-temporal give-and-take between the two modes of expression.

In the Barcelona Pavilion, however, there was no such extreme difference in size to be exploited; hence the solution there is in some respects even more instructive. But to understand it fully we need to

know something about the pavilion's unusual function. Its only explicit purpose was to house an event—to provide a ceremonial setting in which the king of Spain would sign a golden book both commemorating the participation of Germany in the Barcelona Exhibition and signaling its return to international good standing a decade after the First World War. However significant this event may have seemed from a diplomatic point of view, the task of housing it could hardly be construed as a building program. And just as there was no real building program, so there were no budget restrictions. As Peter Blake comments, "Money seems to have been no object: somehow Mies was able to specify . . . the most precious materials available to any architect."[4] Thus, Mies was commissioned less to design a building in the usual sense than to create a pure cultural symbol—an architectural abstraction—seemingly an architect's fondest dream come true. And yet, as Mies appears to have realized, a pure architectural abstraction risks becoming little more than an elegantly conceived architectural toy.

The pavilion's very lack of function increased the desirability of providing it with an ideal or archetypal inhabitant, and how better to do this than with a piece of sculpture—and not just any sculpture but an explicitly humanistic figure-in-the-round? Here one can only speculate, for Mies was notoriously circumspect about his work.[5] But everything about the placement of the sculpture—the way it was framed by the innermost passageway running the length of the pavilion, the scale of the space it was in, and even the orientation of that space to the sun—suggests that some such work was an integral element of Mies's conception. To be sure, the Kolbe was a last-minute substitution for a Lehmbruck, but the harum-scarum scramble to find a suitable replacement can plausibly be regarded as a matter of logistics. Indeed, that so successful a substitution *could* be made is testimony, among other things, to the clarity with which Mies had set the stage, consciously or unconsciously, for just that kind of sculptural statement. Had the situation not called for a contemporary German work, he could as easily have employed a Maillol or even a Hellenistic figure to create essentially the same effect. Finally, we come to the manner in which Mies exploited the demand of the self-contained work of art: to perceive it in all its complexity, *we must come to it.* Like the greatest architects of antiquity and the Middle Ages, Mies

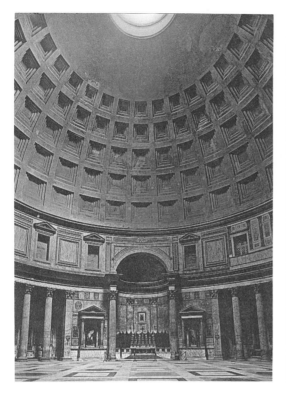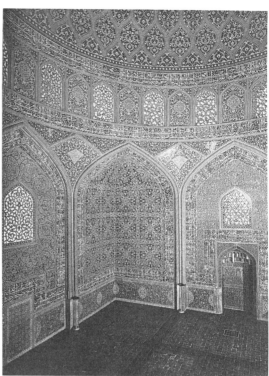

Figures 23 and 24.    The Pantheon, Rome. A.D. 118–25 (*left*); and interior of the Masjid-i-Shaykh Lutfullah.

used the natural attraction of art to lead viewers where the overall sense of the situation required them to go.

To this point we have been concerned primarily with the relation between architecture and sculpture, but gradations of magnitude can help us to understand differences between painting and sculpture as well—or, more precisely, between the pictorial and sculptural modalities. For in any work, whatever its technical medium, it makes a big difference which magnitudes are emphasized and which subordinated. To the extent that the larger magnitudes, that is, parts and bold-element patterns, dominate a work, it takes on a sculptural substantiality. To the extent that fine-element patterns, textures, and colors dominate it, it takes on a pictorial *in*substantiality. These tendencies will hold in either case, even when the primary modality is architecture. For example, the bold coffers in the dome of the Pantheon (Fig.

23) would be almost oppressively corporeal if they were not played off so effectively against the void of the oculus, whereas the intricate tilework of the Masjid-i-Shaykh Lutfullah (Fig. 24) has the effect of dematerializing its surfaces, inside as well as out. A basic strategy of the minimalists was to hyper-monumentalize even their smallest works by treating them like visual paragraphs of one syllable, so to speak— something that Mondrian never sought to do even in his most severe paintings. In early medieval art the contrast between the largest magnitudes and the smallest is often so diagrammatic, with the crucial details played off against largely unmodulated background areas, that even the most schematic and otherwise two-dimensional figures are imbued with a monumental dignity.

This contrast of magnitudes, which easel painting neither presupposes nor requires, is nonetheless a means of establishing a relation between painting and architecture. To be persuaded that this is so, one need only compare the *Entombment of Christ* from Sant' Angelo in Formis (Fig. 25) with Picasso's *Girl Before a Mirror* (Fig. 26), which by any other standards would be considered the bolder painting. Although it is indeed bolder in the purity, variety, and tonal contrast of its colors and in the complexity of its anatomical distortions, it is far less bold in the quality with which we are concerned here. Compared with the dramatic contrast of magnitudes in the fresco, Picasso's forms tend to fall in the middle range and to create a far more purely pictorial, "overall," quality. But it would be a grave mistake to trade in one misconception for another. If bold painterly form à la Picasso is not necessarily monumental form, neither is the painterly handling of detail necessarily incompatible with monumental form. What finally counts is how effectively such detail is played off against the larger forms. As Kenneth Clark points out in his analysis of the monumental element in Rembrandt, an etching like the *Christ Presented to the People* (Fig. 27) "has the unified structure of a composition which could be enlarged till it filled a whole wall." Detail is employed to *complement* monumentality: "If the great conceptions of his later drawings and etchings had been carried out on the scale implicit in their design we should have had a series of masterpieces unlike anything else in art, rich, mysterious, human, evocative, and yet constructed with the architectural logic of a renaissance fresco."[6]

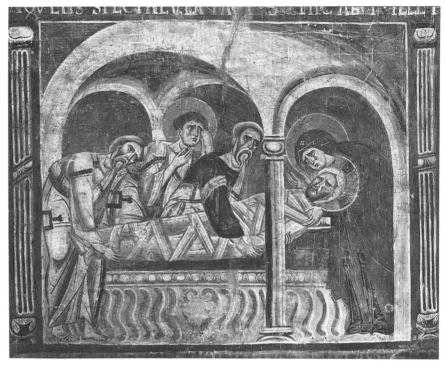

Figure 25. *The Entombment of Christ.* Sant' Angelo in Formis (near Capua). Late eleventh century.

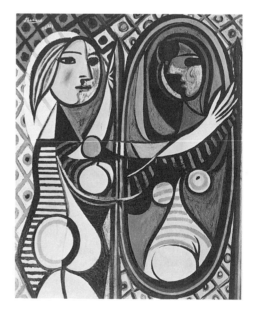

Figure 26. Pablo Picasso, *Girl Before a Mirror*. 1932. Oil on canvas, 64 × 51¼ inches. Collection, The Museum of Modern Art, New York. Gift of Mrs. Simon Guggenheim.

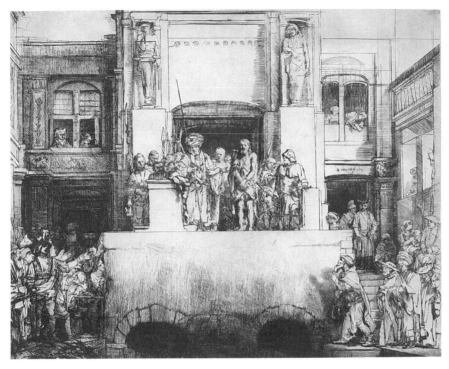

Figure 27.    Rembrandt, *Christ Presented to the People*. Etching, last state, 13 1/16 × 17 15/16 inches. Metropolitan Museum of Art, Gift of Felix M. Warburg and his family, 1941.

Equally instructive are such oxymoronic effects as the tenuous monumentality cultivated by Roman decorators and deplored by Vitruvius in the first century B.C., effects later exploited by the sixteenth-century mannerist painter Parmigianino and the turn-of-the-century illustrator Aubrey Beardsley. In all such works some elements are deliberately defined, massed, and played off against one another to create a sense of abnormally great size; other elements are just as deliberately complicated, proliferated, and dispersed to create the effects of preciousness, transience, and instability—or, as architects would say, a complete "*lack* of scale."

*Illumination in Two- and
Three-Dimensional Art Forms*

In any three-dimensional medium differences in the intensity of the light on the parts of an object create a play of light and shadow. Inevitably some parts receive more light than others or intercept light that

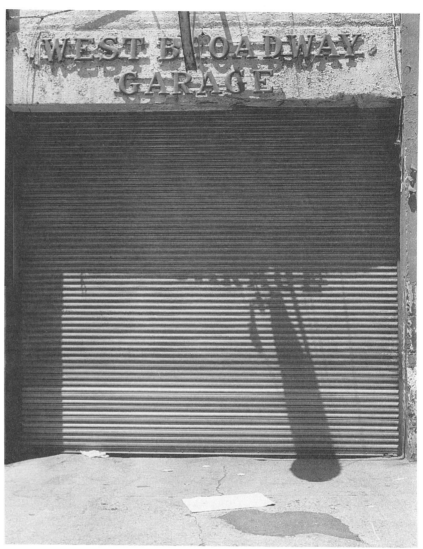

Figure 28.    Tonal values created by shadows.

might otherwise illuminate other parts. If the light comes from a single point, those differences in intensity are more extreme and more clearly articulated. Thus the darkest element in Figure 28 is the massive configuration of shadows cast on a garage door by a clear midday sun. Such configurations, which are undesigned, are also highly transitory. An hour after the photograph was taken, the whole façade, which faces east, would have been obscured by shadow.

By contrast, the *effects* of light and shade in any two-dimensional

Figure 29.    Tonal values created by darker and lighter colors.

medium—and thereby of three-dimensional space or illumination as well—are produced when light is reflected by the darker and lighter colors of the medium applied to an essentially flat surface. But whereas those effects of light and shade are both designed and stationary, they could not hold their own in the harsh light that brings the nondescript garage front temporarily to life. They become fully intelligible only in diffused light, like that in Figure 29, where the dark and light values of everything—two-dimensional painting and three-

dimensional viewer alike—are determined almost completely by the way that local colors reflect the light. Diffused light is the preferred illumination not only for viewing pictures in museums and galleries but also for painting them; it is obviously the light in which Manet painted *this* painting.[7] (Hence the striking similarity between the strong local color contrasts in the clothing of both the painting's subject and the viewer.)

Normally, one type of illumination does not occur to the exclusion of the other; we expect and can usually count on some combination, however one-sided, for our visual orientation. But let us assume, for present purposes, a variable running the gamut from the light and shadow that are determined to the greatest possible extent by light intensity to those determined to the greatest possible extent by light reflectance. How would that variable affect our understanding of the relation between the visual arts?

First, it would help to explain why the sculptural arts can command vast spaces, particularly outdoor spaces, with ease and authority unrivaled in the pictorial arts (see Fig. 2). For the same chance play of light and shadow determined by light intensity that endlessly reveals the animation and articulation of sculptural form can only confuse the nuances of pictorial form, which are determined by light reflectance. Second, and more significant, it would help us to understand how architecture imbues natural daylight with distinct habitation-defining qualities by deliberately varying the size, number, orientation, and overall light-admitting capacity of the apertures in any enclosed space. In the upper nave of Tournus Abbey (Fig. 30), for example, the windows are few and relatively small, and they create a luminous environment that is both subdued and static in its overall effect. Into that luminous environment, however, the south clerestory windows admit the direct rays of the sun—intense, vibrant, focused light that defines its own perimeters in great circles on the floor, casts the shadows of the north arcade into the north aisle, and thereby establishes itself as an almost animate, if intangible, presence in this otherwise austere setting.

Our photograph appears to have been taken near midday, but it is not hard to visualize those great circles of light moving more or less toward the camera position as the day progressed and ending up

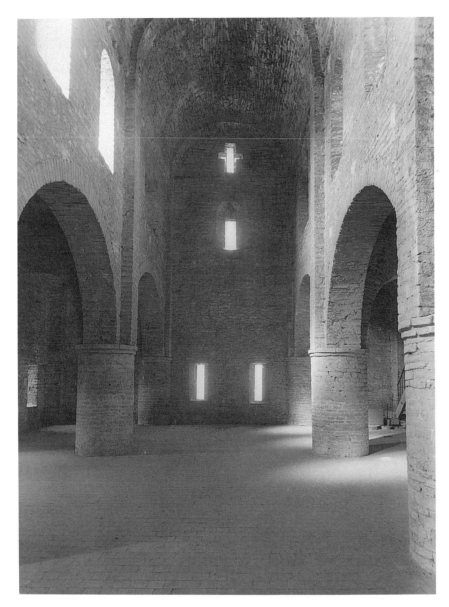

Figure 30.    Natural light transformed by enclosure. St-Philibert Abbey, Tournus. Early eleventh century.

somewhere behind it. And as the sun began to set, the light coming through the narrow slit windows in the west wall, which here seems to be almost physically compressed, would take fire and come lancing horizontally through the nave from end to end. What we see here, in short, is an inert, powerfully sheltering luminous environment within

which a dynamic, form-articulating light is judiciously admitted to display the rounds of our days and seasons, always subject, of course, to the vagaries of intervening weather conditions.[8] Suffice it to say that such effects are fundamentally unlike anything that can be achieved with artificial lighting. Although easily rhapsodized, they are not static, nor can they be technically programmed to do what they do by the flick of a switch or the roving of a spotlight. Little wonder that Louis Kahn loved to repeat the poet's question to the architect: "What slice of the sun does your building have?"[9]

In other structures radically different effects of light are achieved. The huge central oculus of the Pantheon, for example, funnels a diffused light straight down into a symmetrical space but dramatically accents it with the oblique and ever-shifting rays of direct sunlight. The massive window-punctuated south wall of the chapel in Ronchamp creates a veritable brass choir of sunshafts from mid-morning to mid-afternoon that is utterly unlike the effect that same wall would have if it faced north, always away from the sun, or east or west, with its illumination subject to the extremes of dawn and dusk. Despite the many utilitarian blessings of artificial lighting, our greatest architects therefore continue to rely on the unique expressive qualities of natural light. As Kahn himself put it, "A space can never reach its place in architecture without natural light. Artificial light is the light of night expressed in positioned chandeliers not to be compared with the unpredictable play of natural light. The vault, the dome, the arch, the column are structures related to the character of light."[10] And painters rightly prize a north skylight for qualities that it alone can fully provide: a light that is not only diffused and minimally affected by changes in the position of the sun but also—of almost equal importance—alive to the multifarious moods and colors of the sky in all their revealing complexity. By comparison, the constant brightness and color temperature of artificial light are always arbitrary, if not sterile.

Finally, we can see how such a polar variable of illumination would combine with the polar variable of scale, just as the polar variable of hue saturation combines with that of tonal values. For example, reflectance-determined darks and lights applied to the surfaces of three-dimensional forms can effectively simulate forms of a larger or

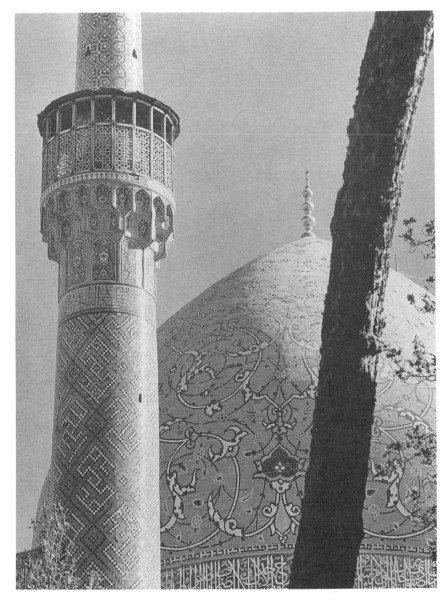

Figure 31.    Shadows and reflections interacting with surface patterns.
*Madrasa* Mader-i-Shah, Isfahan. Early eighteenth century.

smaller degree of magnitude than those actually present. This is the
stock-in-trade of camouflage—to be seen not only in the excesses of
baroque art that become all but indistinguishable from stage props but
also in the protective coloring of animals and insects. By the same to-
ken, the bold play of intensity-determined light and shade on purely

repetitive surface patterns can vary and enliven their overall effect far beyond what we might at first imagine from seeing a small sample of such a pattern. The glazed tilework on the domes of Islam (Fig. 31), highly reflective, always turning both toward and away from the harshest light, is a classic case in point.

Absolutely essential to both the color circle and the theory of primary modalities that we have been exploring is the triad of irreducibly distinctive elements on which each one is based—the primary colors in the first case and the primary modalities of visual expression in the second. Only because they are truly distinctive can they occupy the pivotal positions in their respective systems. Equally essential to both is the infinite combinability of their primaries. Only because of this can we visualize a realm of visual expression comparable to the realm of color combinations. But just as the realm of possible color combinations is greatly expanded when we take into account all the colors that can be created by varying the hue saturation and the tonal value of the three primary colors, so the realm of possible modality combinations is expanded when we take into account all the modality-qualifying effects that can be created by varying the elements of scale and the diffusion qualities of natural light. Thus do the visual arts, so much more complicated than colors in every other respect, similarly function as complementary elements in an orderly whole.

# ON ARCHITECTURE AND ITS "ALLIED ARTS"

Concern for the role of art in architecture, mounted on castors and trundled from one dispiriting conference to another, has long threatened to expire almost unnoticed under a thick blanket of woolly obiter dicta. Among these is the assertion that art and architecture can no longer be "integrated"; they can only be "juxtaposed." We have already had occasion to question the validity of the distinction, but it deserves closer examination. To juxtapose means nothing more or less than to place side by side—hardly the most perceptive description of any aesthetic relation. And to integrate is to form into a functioning whole. How then ought we to interpret the towers of Chartres? Without question they are an integral part of the cathedral, both physically and expressively (see Fig. 68). Yet one is pure Romanesque and the other, completed 350 years later, is flamboyant Gothic. There they stand side by side, neither one stylistically reducible to the terms of the other. Very well, then: are they integrated or juxtaposed? Conceived as an either-or choice between unity and duality, absolutes that are inviolate and irreconcilable, the relation between art and architecture becomes a hopeless paradox. But just as the relation between black and white is neither one thing nor a ragtag collection of things but a seamless scale of gray values, so in this case: once we take into account all the elements that actually can unify or separate art and architecture to varying degrees, the paradox disappears and the range of possibilities becomes apparent.

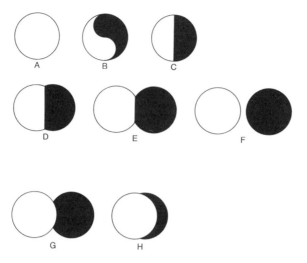

Figure 32.    The unity-duality scale.

Because this point is essential to understanding what follows, let us underscore it with a diagram (Fig. 32). We begin at A (unity); B represents the reciprocal inflection of two elements, C a flat accommodation between them, D their incipient striving for mutual independence, and so on, until we reach F (duality). G and H show further inflections, with the greater or lesser domination of one element by another. Here, then, we see what from an expressive point of view can be called several distinct modes of relation between two elements—modes that we have no trouble recognizing when we return to the real world of architectural art.

No such mode is inherently more valid or less subject to abuse than another. It is simply more or less technically feasible, economically possible, or expressively telling in a given situation. And realizing this, we find ourselves coming back to something resembling the traditional concept of artistic "decorum," long in such disrepute that it has come to mean almost the opposite of what it originally meant. Properly understood, it is a matter of artistic behavior: how in the particular situation, whatever it may be, can the various modes of expression most effectively address one another? Properly understood, the question is as liberating as most legalistic rules of etiquette and decorators' notions of good taste are stultifying. But to understand how specific modes of ex-

Figure 33. *Left*, chapter 3: an art form oscillating between the pictorial and the architectural modalities; *center*, chapter 4: the realm of visual expression dominated by pictorial-modality assumptions; *right*, chapters 5 and 6: the process of mutual accommodation between architecture and its "allied arts."

pression actually do interact with one another—sometimes for better and sometimes for worse—we require a far more concrete and extended set of analyses. That is what we shall now undertake (Fig. 33).

Chapter 3 demonstrates how stained glass, an art form that combines some but not all the qualities of both painting and architecture, oscillates between the pictorial and architectural modalities. Chapter 4 shows how the very concept of architectural art begins to atrophy in a culture like ours, in which all the visual arts have long been dominated to a greater or lesser degree by pictorial-modality assumptions. And finally, chapters 5 and 6 challenge some long-standing assumptions about how artist and architect work together, showing how they frequently have no choice but to exploit difficult constraints of site and use.

# III STAINED GLASS: PAINTING WITH STRUCTURE AND LIGHT

The art of stained glass emerged in the Dark Ages as a simple ornamental adjunct to architecture, developed into a major determinant of architectural form in the early Gothic cathedral-building era, and then became more and more derivatively pictorial until it had little or no relation to architecture. In the last hundred years it has wavered between the ornamentalism of art nouveau, the pictorialism of Chagall, and a new architecturalism in Germany, and it remains one of the least understood forms of visual expression. Yet because of the singular qualities of the medium itself—stained glass transmits light; its leadlines perform both a design and a structural function; and painting in the earliest and greatest windows is little more than an elegant form of colorless brush drawing—we can identify with unusual precision the material, technical, and stylistic forces at work in these successive incarnations. What follows, therefore, is less a historical or even a stylistic analysis than one that shows how specific qualities of the medium have variously combined to affect the oscillation of this art form between the pictorial and architectural modalities.

## The Primal Fusion of Structure and Light

"When I choose an order of structure that calls for column alongside column," Louis Kahn once said, "it represents a rhythm of no light, light, no light, light, no light, light" (Fig. 34). On another occasion he

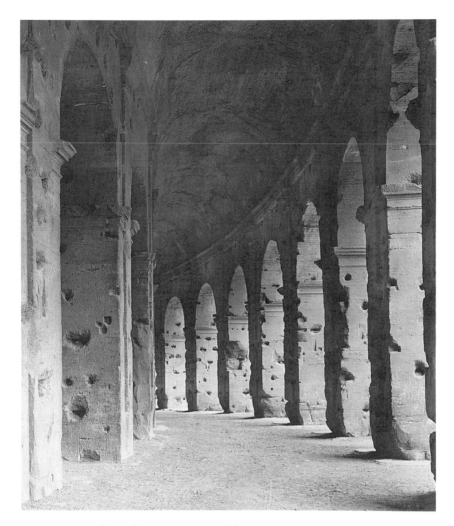

Figure 34.    The Colosseum, Rome. About A.D. 80.

declared that "of all the elements of a room the window is the most marvelous"[1]—marvelous because when light is channeled through a window opening, all of its most vital qualities as light source and primordial clock are concentrated as nowhere else. But aside from its almost gravitational fall through the window opening, natural light has no form. It is a distillation of what is most immediate, transient, and emotionally affective in our visual experience—all the vowel-like qualities that the more consonantal elements of visual expression articulate. If we apply Kahn's "no light, light" rhythm to the physical structure of a window, we realize—as the whole vernacular tradition

Figure 35. Bamboo latticework window, Japanese pavilion, Brooklyn Botanic Garden.

Figure 36. Wrought-iron armatures for stained glass windows in Chartres: *left*, for the *Life of Christ* window, mid-twelfth century (see Fig. 20); *right*, for the *Death and Assumption of the Virgin* window in the south aisle of the nave, early thirteenth century. Whereas the former is purely functional, the latter has become a powerful ornamental bridge between the glass and the architecture. Both, however, are auxiliary to the overall effect of the windows, whereas the bamboo latticework of Figure 35 is a rudimentary synthesis of both functional and fully realized aesthetic qualities—privacy and security on the one hand and a sensitively balanced grid of structure and light on the other.

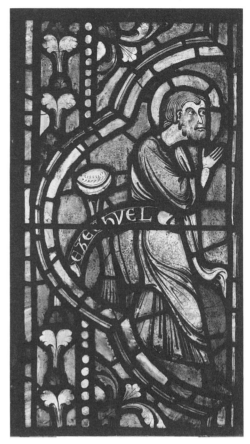

Figure 37.    Figure-and-ground color inversions in the *Ezekiel* panel. French. Thirteenth century. Photograph by courtesy of the Board of Trustees of the Victoria and Albert Museum.

of stone, stucco, and wooden latticework windows dating back to Egyptian times attests (Fig. 35)—why it is possible to create an agreeable ornamental effect even without colored glass. Such windows help us to understand how the art of stained glass could have evolved in the first place—out of the highly articulated ornamental arts of the Dark Ages (Fig. 36)—and, further, how the effort of Renaissance glass painters to duplicate the *appearance* of natural light playing on the subject matter of their images would pit the static pictorial illusion of cast shadows and so on against the dynamic luminous reality—a hopeless contest at best.[2] And finally, the rhythm of "no light, light" helps us to understand why the deliberately *anti*structural or expres-

sionist images of a Rouault or Chagall are only superficially related to the great cathedral windows, despite their bold black lines and glowing colors, and are absolutely unrelated to architecture.

## Reciprocal Inflection

In the early Gothic cathedrals the relation between a highly developed architecture and a highly developed art of stained glass itself developed most highly, and nowhere more than in the ordering of color. Since color was integral to the glass itself, colors in the early windows could not be blended together as in a painting. They could only be deployed, like the tesserae of a mosaic, as discrete pieces of glass, each colored with a single color throughout. But the two major colors in the early windows, ruby and blue, were consistently used to create the kind of intricate inversions of figure and ground shown in a diagram of a thirteenth-century panel depicting the prophet Ezekiel (Fig. 37): The blue (represented by the flat shading) that reads as background for the prophet is brought forward into the floral motifs just above and below him and then drops behind the border motifs on the left. The ruby (represented by the modulated shading) that frames the space in which he stands is divided only by a thin line from more of the same ruby that drops behind the blue floral motifs above and below the figure. And finally, the prophet himself is shown as though he were about to step out of his space. Insofar as the panel is representational, it is ornamentally composed and calligraphically painted; although the field in which Ezekiel stands is framed ornamentally, that frame contains floral motifs that are quasi-representational. Thus there is no fixed point at which the representation begins or ends and no part of it that is not wholly compatible with the overall ornamental character of the *Jesse Tree* window of which this panel was originally a part.

In such ornamental inversions, whereby each part is imbued with the qualities of its neighbor and each level of organization assumes some characteristics of the next, the artists of the period had perfected a means of superimposing one magnitude on another and another on that with cumulative force. Not only were the narrative medallions deployed ornamentally within the windows, but the armatures that supported the glass began to anticipate the next larger structural order of the fenestration itself. At the same time, the lyricism of the narrative images was carried over into the exterior detailing of the window

frames, with their colonnettes and corbel grotesques (see Fig. 20). Thus a vivid linkage of elements was created—part stained glass, part sculpture, part architecture—and not just with these elements. The sculpture of the portals, though endlessly subtle in detail, is grouped architecturally; the two towers, though unmistakably architectural, are handled sculpturally. Almost everything in every scale finds its echo or opposite somewhere.

But this ornamental principle is by no means the only one that the creators of these works exploited. It appears almost as if they had established as a rule of thumb that wherever there was a change—material, technical, or thematic—there should be some strong principle of continuity, something to draw the eye easily and effortlessly across the change. And as a corollary, wherever there was sufficient continuity, the stage was set for the deliberate introduction of some principle of contrast. In fact, the difference between ornamental elaboration—through the repetition, inversion, reflection, and alternation of elements—and overall simplification is not nearly so great as we tend to think. For there comes a point beyond which none of those time-honored principles of ornamentation can be pushed without an overall *loss* of complexity. Consider, for example, the west rose of Chartres (Fig. 38). Although it may seem at first sight to be simpler than the flamboyant rose of Amiens (Fig. 39), it actually rewards far longer scrutiny. For it is a perfect fusion of solids and voids—two elements that are different *in kind*—whereas the Amiens rose is based on the virtuoso exploitation of a single element, the arabesque. It is well on its way to becoming the kind of empty rhetorical flourish that nowadays passes for ornament and has given the concept of ornament a bad name.[3]

What was lost when stained glass became a "lost art"? Not some technical skill—least of all some wondrous technique of coloring glass. More than anything else it was a vital feeling for the process of reciprocal inflection that I have been trying to describe. To be persuaded of this, we need only observe how German artists went about turning stained glass back into a full-fledged architectural art in our own century. They did so by minimizing all the pictorial qualities of the medium that could not be reduced to structure and light—that is to say, the elements of the architectural host, that play of "no light, light"

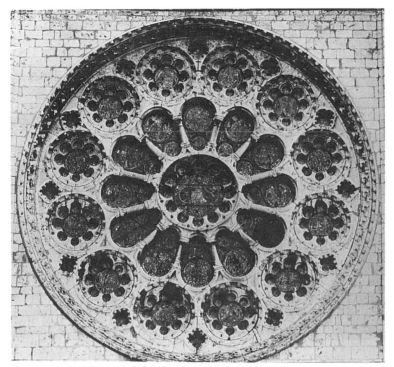

Figure 38.    The west rose window, Chartres. Early thirteenth century.

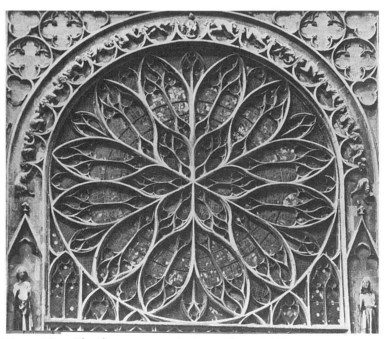

Figure 39.    Flamboyant rose, Amiens. About 1400.

with which we began. Structure in stained glass comprises the support system of both leading and other, more substantial, framing members and the various properties of the glass itself that determine its refraction and limit the ways in which individual pieces of glass can be durably shaped. Thus the German artists used color—and even the colorless form of brush drawing seen in the *Ezekiel* panel—sparingly when they used it at all. They have exploited the bare-bones qualities of the medium with an eloquence unparalleled even in the Middle Ages. And they have done so effectively in buildings medieval and modern, with tiny windows and huge window walls.

Ludwig Schaffrath is the pivotal figure in this development. To observe how he exploited the graphic potential of the leadline is to appreciate the power of such a device in the hands of an artist. Even in his early Karmelkloster windows (Fig. 40) the parallel-leadline schema begins to function like a monumental form of "hatching," and it is coordinated with the windows' heavier structural members so that these are visually absorbed into the overall design. Throughout the 1960s Schaffrath's color remains grave, muted, secondary—his glass translucent rather than transparent, like alabaster. Gradually the organic metaphor in the earlier windows is superseded by an almost crystalline refinement of everything that had gone before, as we see in Frenz (Fig. 41). Then in the early 1970s this refinement gives way to an almost galvanic sense of fluidity and motion, and the parallel-leadline schema becomes an elegant, soaring system of "tracks," as in the huge window wall in Bad Zwischenahn (Fig. 42). Next, in St. Joseph's Church in Aachen (Fig. 43), these kinetic tracks are expanded to the point where they begin to take on figurative connotations, particularly in the long and narrow lancet windows. Simply by pursuing his own ends in his own way, Schaffrath had arrived at the same uncanny balance between rhythmic energy and elongated formal quietude that marks the early portal figures on the west front of Chartres. As Schaffrath has said, he always composes his windows "by working out the design in such a way that it can be 'solved' without color. Most important to me, regarding the leading, is that its holding function and graphic function are identical."[4] Although he has since abandoned the strict parallel-leadline schema (Fig. 44), he continues to insist on these same working principles.

Figure 40.    Ludwig Schaffrath, Karmelkloster, Düren. About 1965.

Figure 41.   Schaffrath, Frenz Cemetery Chapel. 1968.

Figure 42.   Schaffrath, St. Mary's Church, Bad Zwischenahn. 1970.

Figure 43.    Schaffrath, St. Joseph's Church, Aachen. 1971–75.

Figure 44.    Schaffrath, Church of the Sacred Heart, Stolberg-
Münsterbusch. 1980.

Figure 45.    Johannes Schreiter, Johannesbund Chapel, Leutesdorf-on-the-Rhine. 1966.

*Graphic Neopictorialism*

Whereas Schaffrath has accepted all the structural limitations of the medium as axiomatic and has sought by every means to relate his windows to their architectural setting, Johannes Schreiter has systematically challenged those same structural limitations in order to invest his windows with a no-less-authentic pictorial quality. He begins by extending some of his structural leadlines with surface appliqués of lead (Fig. 45) that are quite as free to project into the middle of a piece of glass as to surround it and bind it to its neighbors. Thus he effectively disguises the containing function of the leadlines and transforms them visually into a kind of graffiti—sparse, weightless, floating, fragmented. Next, he begins to reinterpret the parallel-leadline schema. Instead of treating it as a variable motif, he reduces it to a uniform backdrop or foil for clusters of seemingly disordered or fragmented accents, as in Dortmund (Fig. 46): a listless order assaulted by a disaffected randomness. Then he begins to challenge its static two-dimensionality. In his Limburg Cathedral windows (Fig. 47) the parallel lines forsake their former rigidity and become almost like streamers

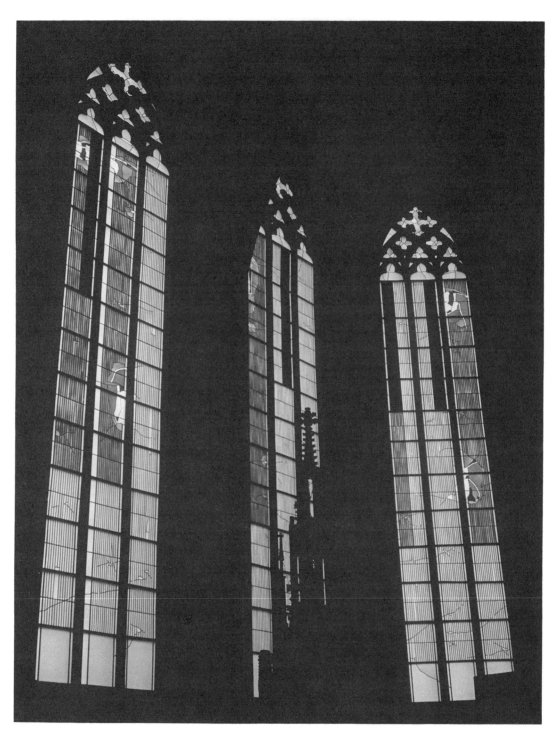

Figure 46.    Schreiter, St. Mary's Church, Dortmund. 1969.

Figure 47.    Schreiter, Limburg Cathedral. 1977.

Figure 48.    Schreiter, Church of St. Lawrence, Niederkalbach. 1978.

Figure 49.    Schreiter, Stained-glass and plexiglas panel. 1978–79.

Figure 50.    Roy Lichtenstein, *Little Big Painting*. 1965. Oil on canvas.
68 × 80 inches. Collection of Whitney Museum of American Art. Purchase,
with funds from the Friends of Whitney Museum of American Art. 66.2.

Figure 51.　Schreiter, College of Art, Swansea. 1980.

peeling away from a surface—but the surface of what? For behind them there appears to be nothing but a somber void. In Niederkalbach (Fig. 48) the window surface is reestablished, this time with an even denser surface pattern of battered quarries that is seemingly rent and partially disintegrated, its border strips almost gleefully detaching

themselves from the window casements. At about the same time Schreiter begins to produce a series of self-contained stained-glass panels (Fig. 49) in which we see forms so complex and attenuated that either they could not be cut out of glass at all or they would break under the least stress if they were. And to be sure, they are not glass but *plexiglas*: if the leadlines need no longer appear structural, why should the glass have to be glass? The tempo of the leadline is quickened once again and takes on the characteristics of calligraphy. Thus it becomes simultaneously a parody of the painted line in thirteenth-century stained glass and the parody of another parody, Lichtenstein's pop-art send-up of the abstract expressionist brushstroke, right down to the flying paint spatter (Fig. 50). Despite the seeming antistructuralism of Schreiter's work, it is as graphically articulated as Schaffrath's more overtly structural forms. At no point, therefore, does Schreiter break faith with the most elemental function of the stained-glass window *as a window*—that vital "no light, light" ordering of the play of light with which we began (Fig. 51).

## Stained Glass vs. Architecture

Of all the prominent painters of the early twentieth century it was Rouault whose paintings were most frequently compared to cathedral windows, not only by the public but also by critics and art historians. Indeed, how could anyone not be struck by the similarities between Rouault's *Old Clown* (Fig. 52) and the great medieval windows, to which H. W. Janson calls attention in his widely read history of art?[5] Yet seldom have appearances been more deceiving. When the best craftsmen in France attempted, with the artist's wholehearted cooperation, to translate some of his paintings into stained-glass windows, the results were a signal disappointment. Why?

The answer depends on an elementary distinction that seems to have been almost completely ignored: the difference between an opaque surface and a translucent window opening as the field on which to compose an image. A blank canvas is almost the ideal instrument of the pictorial modality because it is both neutral and self-contained. The energy and expression in a good oil painting are in the quality of the painting itself. But the window opening with which the stained-glass artist works is neither neutral nor self-contained. Ani-

Figure 52.    Georges Rouault, *The Old Clown*. 1917. Collection of Mr. and Mrs. Stavros Niarchos, Paris.

mated by the play of natural light, it is always to a greater or lesser degree expressively "alive." And because it is framed by some architectural setting, its formal and functional status is always to some extent predetermined. As we have seen, however, the physical medium of stained glass is not as obligingly fluent and manipulable as paint. In

short, the stained-glass window is dynamic where painting is static and static where painting is dynamic. It follows that bold black lines and rich glowing colors are bound to function differently in the two arts—technically, formally, and expressively. And when we look beyond the obvious similarities between a Rouault painting and a thirteenth-century stained-glass window, that is exactly what we find.

As we have already seen, the boldest black lines in the earliest windows are leadlines, which are bound by certain technical considerations. But the brush drawing that was used to render details was not so bound. To be sure, it was essentially colorless and its use was bound by the stylistic conventions of the time—but only up to a point, and it is precisely the differences that are significant. In wall paintings and manuscripts colors are commonly blended or juxtaposed in ways that were technically impossible in stained glass. Only in stained glass is there a system of painted lines that consistently echoes, articulates, and ornaments the bold contours defined by the leadlines. Yet the effect of these windows is anything but dull, for here again, on the smallest possible scale, even the glass painters were ingeniously exploiting the principle of "no light, light."

Rouault's brushwork performs its own very different function with no less consistency and effectiveness. Whether halting, lacerating, or impetuous, it is always broken and irregular, and line often merges almost indistinguishably with mass. And whereas the blending of one color into another was completely impossible in thirteenth-century stained glass, the colors in a Rouault painting are scumbled into one another in the most complex way. The figure-and-ground color inversions in the early windows systematically flattened *and* organized their spatial illusion. By comparison, the space in a typical Rouault painting is neither flat nor three-dimensional. Rather, it tends toward a primitivized three-dimensionality that is intentionally discordant, hallucinatory, and claustrophobic. Quite apart from the technical impossibility of duplicating all these effects in stained glass would be the futility of the effort. The complex nuances of form and color would simply be overwhelmed by the constant changes in the color and intensity of the light passing through the window—leaving an already garrulous and incoherent patchwork of leadlines to fend even more conspicuously for itself. William Rubin's observation that "Rouault's

painterly genius is compromised by translation into stained glass"[6] is perfectly true, but it invites the retort that the art of stained glass is equally compromised when it is translated into Rouaults.

To understand what is wrong with the pictorial approach to stained glass, we need only consider why Chagall's yellow window in Metz Cathedral works as well as it does. First, Chagall has disciplined his color in this window far more than in most of his other stained glass; the whole window is dominated by the one hue. Second, the window opening itself is ornamentally ordered by a strong flamboyant tracery. And third, this particular window is located in the north transept— away from the strongest sunlight, in a huge space, and opposite some of the most powerful and colorful windows by Valentin Busch, one of the leading stained-glass artists of the early sixteenth century. All these factors combine to create an effective foil for the artist's effusive lyricism. Wherever Chagall has not been similarly supported by the architectural setting and has not seen fit to discipline his color in this way, he has simply fallen on his face.

Painters and scholars alike have "over-pictorialized" stained glass and have paid only the most rudimentary attention to its far more elemental architectural attributes—despite the overwhelming evidence of history. For it is almost universally accepted that the greatest stained-glass windows are those created between the mid-twelfth and mid-thirteenth centuries; yet those windows predate every technical advance in the craft of stained glass that would increase its painterly facility later on. And they predate the emergence of easel painting by some two hundred years. How are we to account for such a deep-rooted misconception? Easel painting, far more committed to the nuance and intimacy of its effect than architectural art, isolates its subject from its immediate surroundings, and properly so. Indeed, if my thesis is correct, the genius of the pictorial modality lies in its ability to do just that. But then we must wonder how the intensive cultivation of such self-contained creations over a period of several centuries has affected our awareness of the relation between all the visual arts. That is the difficult question to which we now turn.

# IV PICTORIALIZING THE VISUAL ARTS

To this point I have treated the relations between the visual arts as though they were broad and busy streets with a constant flow of traffic in both directions. But in the real world of art and architecture the full force of visual sensibility cannot be committed everywhere at once. In the great theocratic civilizations from Egypt to the Middle Ages, this force was concentrated on the creation of monuments (and their ceremonial equipment) and fortifications; in the high nomadic cultures, which appear to have existed at the same time, it went into the making of jewelry, carpets, weapons—whatever was both useful and portable. Only during the past five or six hundred years do we find a similarly intensive development of easel painting as the classic instrument of the pictorial modality—a mode of pure envisagement, infinitely malleable and detached as nearly as possible from material, technical, or practical limitations. For present purposes it is less important to ask what was gained by this detachment than to ask what was sacrificed.

If only because the pictorial modality is, as nearly as it can be, a disembodied instrument of visual conception, the visual, technical, and practical experience the artist brings *to* it becomes far more important. This is true no matter how great the artist happens to be. When Michelangelo, very much against his own will, was drawn away from sculpture to paint the Sistine ceiling, he found that he could realize the full potential of the human figure as his own instrument of expression far

more quickly than he could ever have done working in marble. But this achievement in his painting was predicated on his highly developed sculptural vision. When artists paint or draw to develop ideas for execution in a medium with which they have had little or no direct experience, the painting and drawing are far more uncertain instruments.

Consider, for example, Leonardo da Vinci's attempt to work out the ideal plan for a domed centralized church (Fig. 53). His plan is clearly that of a huge structure—more or less on the scale of the soon-to-be-rebuilt St. Peter's in Rome—but his elevation gives the impression of a structure more nearly the size of Bramante's Tempietto. We can only agree with Kenneth Clark that "Leonardo lacked that native sense of interval, of allowing one space to tell against another, which the simplest Tuscan *muratore* can give to a farm building."[1] But in the drawing of the domed church there is another, even more sobering, difficulty. One need only visualize such a structure blown up to the size of St. Peter's or anything near it to realize that the figures with which it is so casually adorned would have to be some forty, fifty, or sixty feet tall— and that at close range they would be seen from what can best be described as a worm's-eye perspective. Unfortunately, no bells ring and no lights flash when the pictorial imagination, untrammeled by any contact with reality, begins to conjure up monstrosities. But this problem, even more than the problem of relation, calls for extended analysis. We shall come at it from four vantage points.

*Representational Space vs. Architectural Space*

Few paintings in the history of art were as carefully thought out or create as indelible an impression as Leonardo's *Last Supper* (Fig. 54). Nonetheless the painting has long existed in a curious limbo, even for Renaissance scholars. Although it is a wall painting that spans one end of the long and narrow refectory of a church in Milan, it has usually been reproduced as though it were "really" an overscale easel painting utterly unrelated to any architectural setting. Thus Kenneth Clark devotes eight pages of his monograph on Leonardo to analyzing this work but says almost nothing about its qualities as a mural, and he reproduces it as though it were a self-contained image.[2] Not until the twelfth edition of E. H. Gombrich's influential *Story of Art*, some twenty years after its original publication and translation into a dozen

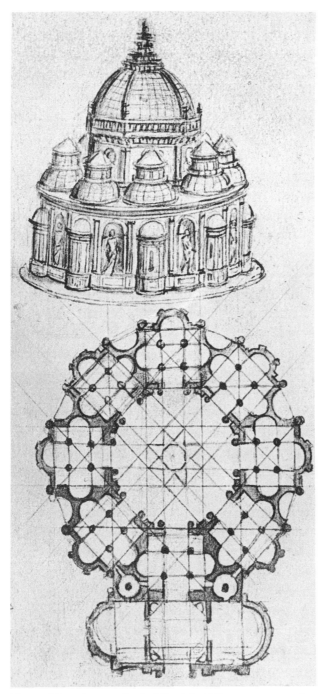

Figure 53. Leonardo da Vinci, Building on a central
plan. End of fifteenth century. Bibliothèque de l'Insti-
tut, Paris.

languages, was *The Last Supper* reproduced in both the usual manner and as part of its architectural setting.[3] No one seeing the work for the first time can fail to be struck by the impression that it creates in situ. And until Leo Steinberg published his brilliant study of the painting, no one had given serious attention to the singular relation between it and its setting. Instead of being put off by the ambiguities in that relation, Steinberg argues that *The Last Supper* is and was intended to be ambiguous in almost every respect and that we cannot grasp the startling originality of Leonardo's achievement unless we take the ambiguities into account. His analysis,[4] which runs for more than a hundred pages, is so thorough and many-sided that I can only recommend it to the reader and call attention to the points most closely related to this discussion.

Most disturbing from a purely visual point of view is what appears at first sight to be an ill-conceived effort to treat the depicted space as an extension of the refectory "beyond" the end wall on which the work is painted—ill-conceived not because it cannot be done (in fact, Leonardo has done it) but because such an illusion can work only from a single vantage point. When pursued to its logical conclusion, the single-vanishing-point perspective system reduces the ambulatory, binocular, flesh-and-blood viewer to a single immobilized eye, optically indistinguishable from the lens of a camera obscura. It is a condition to which few real viewers are likely to submit frequently or for long, even for a masterpiece. But from Steinberg we learn that the perspective lines of *The Last Supper* align themselves with the orthogonals of the refectory at a point some fifteen feet above floor level—a vantage point normally inaccessible to the viewer. When we also learn that the head of Christ in the painting is at this same height, "we accept the representation not as an annex but as an autonomous spatial entity beheld from its own ideal eye level."[5] As Figure 54 shows, even the slightest divergence from that vantage point creates a noticeable disjunction between the depicted space and the actual space: "The picture not only fails to disguise the collision of the real and the painted perspectives; it insists that we never forget just how discontinuous the orthogonals of the two systems are. Instead of veiling a regrettable discontinuity, Leonardo sharpens our experience of it. . . . The perspective becomes, as it were, a consequence of the event" depicted in the

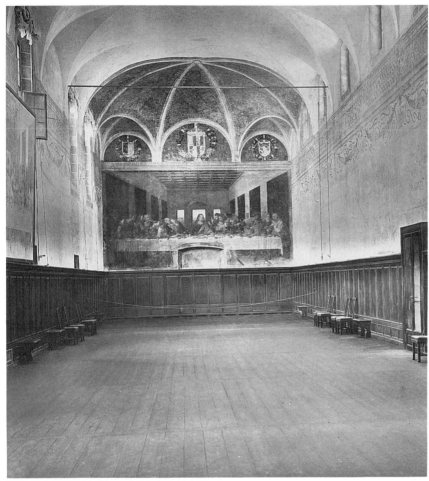

Figure 54.    Leonardo da Vinci, *The Last Supper*, in situ. Santa Maria delle Grazie, Milan. Between 1495 and 1498.

painting.[6] Not only does the apparent clash between the two perspective systems function symbolically, but the space depicted in the painting itself makes sense only when the painting is seen in situ, where it creates "an ambiguous interlock between real and depicted space, with the Lord's table bestriding a frontier between two engaged worlds." And because all the framing cues of the image make it appear to bestride that frontier, the image itself "could never, barring drastic revisions, serve as an autonomous representation of a table inside a room."[7]

No one but another equally gifted Renaissance scholar would be

equipped to challenge Steinberg's interpretation of *The Last Supper* point for point. But if we accept it, we are struck by the lack of real issue from Leonardo's singular achievement: no important contemporary or successor of Leonardo's ever attempted seriously to adopt the same paradoxical strategies for relating a painting to its architectural setting. The exploitation of illusion would become more elaborate, more spectacular, and more decorative; but nowhere, to my knowledge, were its ambiguities exploited as an almost metaphysical device. It is abundantly clear that neither Michelangelo nor Bernini exploited them in this way. Indeed, one is almost tempted to say that they took pains not to do so—as if they felt intuitively that a disrelation by any name is still a disrelation. Even if painting a wall is not the same as painting a vast ceiling, the differences between *The Last Supper* and the Sistine ceiling (Fig. 55) are instructive. In the ceiling, instead of a single vanishing point, there are sixteen or more: five along either side, one at either end of the main axis, four more in the diagonally oriented corner subjects. Instead of Leonardo's chaste and ambivalent framing devices, we are presented with a massive system of trompe l'oeil frames and moldings embellished with caryatidal figures. Nowhere does Michelangelo define his relatively shallow space with anything like the explicit and centered geometry of *The Last Supper*. Instead of exploiting any new or esoteric spatial conceptions, he recalls the composite images of the early altarpieces. Whereas Leonardo's color and light can be interpreted as naturalistic, with the windows high on the west wall of the refectory appearing to illuminate his subjects, Michelangelo's light emanates hieratically from the direction of the altar. His use of color is far more abstract and his employment of visual "rhyming" far more systematic. As Gombrich says, "It is one of the great surprises, when one comes into the Sistine Chapel, to find how simple and harmonious the ceiling looks if we regard it merely as a piece of superb decoration."[8]

If anything, Bernini was even more concerned to avoid any appearance of conflict between levels of reality in his *Vision of St. Teresa* (Fig. 56), which, despite the technical medium, is really a triumph of pictorial artifice. Like the compartmented images of the Sistine ceiling, Bernini's subject is emphatically framed—even more emphatically framed, for here the framing elements are not just painted but mas-

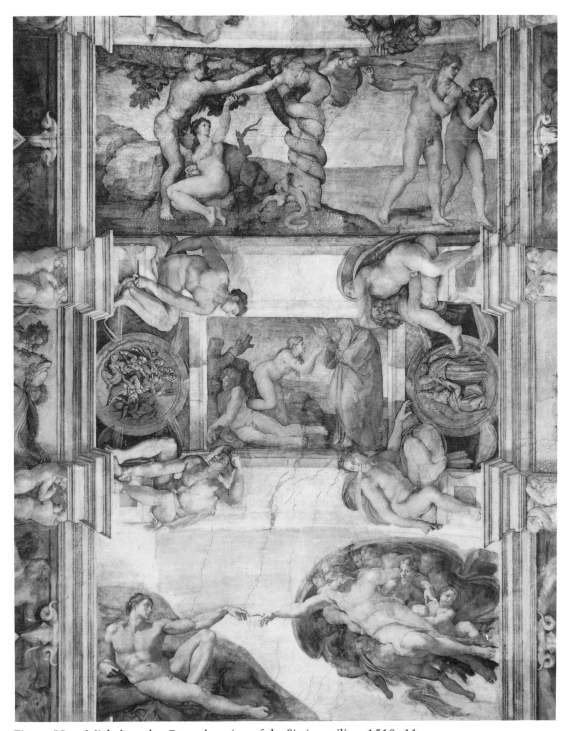

Figure 55.  Michelangelo, Central section of the Sistine ceiling. 1510–11.

sively real architectural members. The space in which the *Vision* appears is shallow, parallel to what might almost be called the "picture plane," and animated by the striations of the marble and stylized rays of golden light that appear to be lancing down behind it. Save for those golden rays, Bernini's colors are the natural colors of the stone itself, richly mottled and toned down in the background, bright and luminous in the figures. And to illuminate this tableau, Bernini artfully channeled natural light through a concealed skylight. In short, he employed theatrical means to create an almost apparitional image, using sculpture as his technical medium. At the same time, however, the illusion is aesthetically distanced because the marble is visibly marble rather than flesh; and the viewer is not immobilized by the geometric requirements of three-dimensional perspective.

In the Gesù (see Fig. 65) and elsewhere, the great baroque ceilings are all massively framed, highly animated, teeming with visual incident and dominated by organic forms—clouds and swarms of gravity-defying figures seen from unprecedented angles that seem more nearly to vaporize the coordinates of architectural space than to be bound by them. Not until our own time do we find three-dimensional perspective employed as a problematic extension of architectural space; and there, as in the work of Richard Haas (see Fig. 72), the effect is almost invariably ironic—often stridently so.

### Contextual Myopia

Far more significant for present purposes than the painter's conquest of three-dimensional space as such is the sense of visual completeness or self-containment that the art of easel painting tends to produce even when the painted images are austerely nonobjective. To the degree that such autonomy comes to be accepted as a criterion of "fine" as distinguished from "applied" art, any *relation* between art and architecture is bound to seem moot or paradoxical—and therefore to be bracketed out by artist and interpreter alike. An almost classic case in point is the Church of Assy, which was decorated by several of the leading artists of France in the years immediately following World War II (Fig. 57). Because of the stature of these artists, the clerical reaction to their work, and the attendant publicity, Assy has continued to be a springboard for conclusions not simply about the validity of con-

Figure 56. Gianlorenzo Bernini, *The Vision of St. Teresa*. Cornaro
Chapel, Santa Maria della Vittoria, Rome. 1646.

temporary church art but about contemporary architectural art in general. The earliest, most thorough, and most scholarly study of this singular project is William Rubin's doctoral dissertation, completed in 1958 (less than a decade after the church was consecrated) and subsequently published. Not only was Rubin able to interview several of the principal artists involved in this project, but he also acknowledges the criticism and advice of two art historians of the highest caliber: Meyer Schapiro, the sponsor of his thesis, and Rudolf Wittkower, who was chairman of the Department of Fine Art and Archaeology at Columbia University, where Rubin earned his degree.

Without recognizing the full implications of his own account, Rubin tells in fascinating detail how the various artists were engaged, almost catch-as-catch-can: in all, eleven artists, two artisans, and an artist-priest. There were to be stained-glass windows by the painters Rouault, Berçot, and Bazaine, the artisans Paul Bony and Marguerite Huré, and the priest, Marie-Alain Couturier; a mosaic by Léger; tile murals by Matisse and Chagall; an altar painting by Bonnard; a crucifix by Germaine Richier; a baptismal font by Lipchitz; a tapestry by Lurçat; and a relief for the tabernacle door by Braque. Of the eleven artists only four, Lurçat, Lipchitz, Bonnard, and Richier, were to work in their own media; and only Lurçat, Léger, Lipchitz, and Matisse had had any experience with architectural art. Moreover, when Assy was being decorated, these were already the grand old men of the Paris school: Chagall was born in 1887, Braque in 1882, Léger in 1881, Rouault in 1871, Matisse in 1869, and Bonnard in 1867. Furthermore, not only age and infirmity but also prestige combined to isolate some of these artists from the working experience in which a new medium is best mastered. And finally, the Paris-school tradition in which these artists had been formed was probably less spiritually concerned than any other tradition in the history of art—in marked contrast to the Germanic tradition, from Munch, Nolde, Ensor, and Caspar David Friedrich all the way back to Dürer, Schongauer, Bosch, and the Middle Ages.

Surely in all these elements it should have been possible to discover compelling reasons why *this* project was bound to fail. But Rubin seems to have assumed that a harmonious interaction between tapestry, mosaic, stained glass, tile murals, sculpture, bas-relief, and archi-

Figure 57.   Plan of Notre-Dame-de-Toute-Grâce, Assy, showing location
of principal works of art.

tecture would spontaneously generate itself. Thus he treats us to an orthodox formal and iconographic analysis of the individual creations and from that derives his conclusion: "Modern churches will be built, and occasionally a great modern painter will decorate one of them, but reunions of masters, such as the church of Assy witnessed, will probably never take place again."[9]

Are such "reunions" (if that is what Assy deserves to be called) necessary or even desirable for the creation of a coherent relation between art and architecture? As Rubin analyzes it, Assy resembles nothing so much as a surrealist project, in which several artists would work on parts of a single canvas without any knowledge of the others' contributions precisely to create an effect of *dis*unity. *Cadavres exquis* they were called, and the desired effect was readily achieved.

A decade after Rubin's analysis the Jesuit art historian Thomas Mathews argued that the "basic fallacy behind the great experiment of Assy" was the belief that religious art could be commissioned: "The commissioning of this or that subject for this or that wall space involves a fundamental compromise of artistic freedom. However well it may have worked in past ages, to paint on commission is entirely alien to the uncompromising pursuit of an interior vision."[10] Stern words, with which many contemporary artists would wholeheartedly agree— but they do not happen to square with what we know about the artists who worked on Assy. For none of them was under any conceivable obligation to accept a commission; if anything, quite the opposite. Rouault, long recognized as the foremost living Catholic artist, had been systematically snubbed by the church; Chagall and Lipchitz were Jews, Léger and Lurçat Communists; most of the others were agnostics. In fact, Léger had long espoused the desire "to realize and renovate a contemporary collective, popular mural art,"[11] and the depth of Matisse's interest in decorative art is only now beginning to be fully appreciated. Not only did he design the Vence chapel and all its fittings, but he also helped to pay for it out of his own pocket. This is hardly the behavior of an artist who felt that commissions threatened the "pursuit of an interior vision." The attitude with which these artists approached their task is perhaps best summed up in the inscription that Lipchitz placed on his sculpture: "Jacob Lipchitz, Jew, faithful to the religion of his ancestors, has made this Virgin to foster understand-

ing between men on earth that the life of the spirit may prevail."[12]

In 1979 John Dillenberger attempted to salvage something from Assy in a re-review of Rubin's book for the journal *Art Criticism*. Dillenberger questions Rubin's unusual concern for traditional iconography, paired as it is with a "penchant for formalist non-meaning";[13] but nowhere does Dillenberger suggest that the fusion of formal, functional, and symbolic elements in a church, so brilliantly summarized in Rudolf Schwarz's drawing of a Gothic cathedral (see Fig. 3), is a *deliberate creation*. From beginning to end, Assy reveals nothing so consistently as a cultivated incapacity to see the forest for the trees.

*Expression vs. Function*

If our age is indeed dominated by the pictorial vision, we should expect to find not only the high development of easel painting but a tendency for all the other arts to assume the special prerogatives of easel painting, however consciously or unconsciously, awkwardly or irresponsibly. Nowhere have the results of that tendency created more havoc than in architecture, which for practical as well as expressive reasons can never be reduced to an art of pure appearances and completely detached from its visual surroundings. When treated as a mode of self-expression similar to abstract expressionism, architecture breaks out in a rash of violent skin diseases. And architectural criticism, honing in on some particular manifestation of the disease, may itself be afflicted with another.

Particularly instructive for my present purpose is the book *Learning from Las Vegas* by the architects Robert Venturi, Denise Scott Brown, and Steven Izenour.[14] Like Venturi's earlier *Complexity and Contradiction in Architecture*,[15] this book is brilliant, blunt, polemical, and not above using sheer perversity as an attention-getting device. But it is thought-provoking in the best possible sense of that term, and nothing that follows should be taken as a judgment on the book as a whole.

For the Venturi team the evils of Modern, or as they prefer to call it, "heroic and original,"[16] architecture are clear. Instead of being truly functional, it has employed a grandiose machine-age rhetoric to suggest "reformist-progressive social and industrial aims that it could seldom achieve in reality" and "while rejecting explicit symbolism and frivolous appliqué ornament, has distorted the whole building pro-

gram into one big ornament."[17] Translated into the terms of this study, the great sin of Modern architecture is that it employs a repertoire of functional-*looking* sculptural elements to create an irresponsible monumentalism. To counteract such evils the authors advocate an "ugly and ordinary" or "decorated-shed architecture":[18] conventional construction, with two-dimensional vernacular detail applied to the surface. Finding the rationale for such architecture in astute pragmatic observations, dubious perceptual speculations, and even populist panegyrics, the Venturi team draws conclusions as straitjacketed as those they repudiate.

We begin with their perceptual speculations. "Articulated architecture today is like a minuet in a discotheque, because even off the highway our sensibilities remain attuned to its bold scale and detail. Perhaps in the cacophonic context of our real landscape we are impatient with any architectural detail at all."[19] Perhaps. But then again, perhaps not. The sensibilities of our ancestors in the great age of the minuet do not seem to have been similarly affected by the cacophonic bump and clatter of the horse carriage. If we grant that there is such a thing as a "highway sensibility," then from almost any point of view, whether legibility and driver safety or commercial effectiveness, such a sensibility ought to take priority in the design of highway-related facilities. And if the highway on which we now spend so much of our lives can be thought of as a high-speed mode of habitation, a good case can be made that architects ought to be not only concerned with it but willing to learn from it. Neither the experience nor the architecture of the past can provide us with any real precedents. To the great credit of the Venturi team, they make that case in *Learning from Las Vegas*, but in the process they get carried away by their own thesis. The Las Vegas Strip, after all, is a special case—a road-town "critical mass." However workable or spectacular it may be as a tourist attraction, it can hardly be taken as a model for other environments that serve fundamentally different needs. What works on the Strip creates a very different effect when transposed to suburban residential streets:

> In suburbia the eclectic ornament on and around each of the relatively small houses reaches out to you visually across the relatively big lawns and makes an impact that pure architectural articulation could never make, at least in time, before you have passed on to the next house. The lawn sculpture partway between the house and the curving curb

acts as a visual booster within this space, linking the symbolic architecture to the moving vehicle. So sculptural jockeys, carriage lamps, wagon wheels, fancy house numbers, fragments of split-rail fences, and mailboxes on erect chains all have a spatial as well as a symbolic role. Their forms identify vast space as do the urns in Le Nôtre's parterres, the ruined temples in English parks, and the sign in the A & P parking lot. . . . To call these artifacts of our culture crude is to be mistaken concerning scale. It is like condemning theater sets for being crude at five feet or condemning plaster *putti*, made to be seen high above a Baroque cornice, for lacking the refinements of a Mino da Fiesole bas-relief on a Renaissance tomb.[20]

In fact, these self-styled connoisseurs of suburbia are themselves mistaken about scale—about *which* scale ought most to concern them. For—must we spell it out?—suburbia is neither a baroque setting nor a theater set; people live there amid the so-called artifacts, or "doodads," as they become in the next and most revealing sentence: "Also, the boldness of the suburban doodads distracts the eye from the telephone poles that even the silent majority does not like." If Modern architecture is to be condemned for grafting a sterile machine-age look on everything it touches, what are we to say about an architecture that would treat the residential environment of suburbia as split-second entertainment for through traffic? It may be less stuffy, but is it any more responsible?

Venturi et al. have persuaded themselves that all monumental form in contemporary architecture is *necessarily* ineffectual and irresponsible. Therefore all such form must be categorically rejected. Architecture, taking its cue from the most denotative content of painting, must become conventional construction to whose surface two-dimensional ornamentation is "applied." No one looking at the work of Louis Kahn (Fig. 58) and Ludwig Leo (Fig. 59) is likely to find himself similarly persuaded.

## Modernist Painting as the Beleaguered Exemplar of Visual Expression

In 1967, when minimalist art was at the peak of its influence, the critic Michael Fried challenged what he termed its literalist qualities—its deadpan "objecthood" or look of nonart: "What is it about objecthood . . . that makes it, if only from the perspective of recent modernist painting, antithetical to art?" Fried's answer was that it amounted

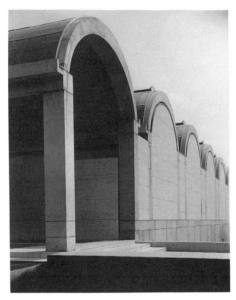

Figures 58 and 59.    Louis Kahn, Kimbell Art Museum, south facade, Fort Worth, Texas. 1966–72 (*left*); and Ludwig Leo, Hydraulic pumphouse. Havel-Berlin. 1969.

to "a plea for a new genre of theatre; and theatre is now the negation of art." The literalist sensibility is theatrical and to be deplored because (and the italics are his) "the experience of literalist art is of an object *in a situation*—one that, virtually by definition, *includes the beholder*." Everything the viewer observes, including the varying conditions of light and the spatial context, "counts as part of the situation and hence is felt to bear in some way that remains undefined on his experience of the object."[21] We might grant for the sake of the argument that such qualities are indeed antithetic to *easel* painting. That is a long way from establishing that they are antithetic to the visual arts as a whole, that they are uniquely or essentially theatrical, or that they are now the negation of art.

Far from being antithetical to the visual arts as a whole, the experience of art as an object in a situation that includes the beholder is as ancient and honored as Stonehenge; as highly developed as Vincent Scully shows it to have been in the siting and shaping of the Greek temples;[22] as unexpectedly alive and well as it proved to be when Richard Serra's *Clara-Clara* (Fig. 60) was installed in the Place de la Concorde. Nor can it be shown that such qualities are uniquely or essentially the-

Figure 60.    Richard Serra. *Clara-Clara*. Place de la Concorde, Paris.
1983–84.

atrical. On the contrary, the spatial qualities that most distinguish the
theatrical arts from the visual arts properly so called are *kinetic*—the
product less of any particular physical situation or object than of the
performance itself. As Rudolf Arnheim says, "Distance is created by
actors withdrawing from each other; and the particular quality of cen-
tral location is brought to light when embodied forces strive for it, rest
at it, rule from it."[23] Far from being the negation of art, such perceived
tensions and their resolution are one of its most universal attributes.
But for Fried the visual arts, which he nowhere defines, are like dis-
crete islands of probity in a sea of nonart: *"What lies* between *the arts
is theatre"* (again his italics);[24] as he uses the term *theatre*, it functions
as little more than an omnibus pejorative. In the last analysis Fried's
attack on what might better be called the literalist dogma becomes
every bit as involuted, intolerant, and ineffectual as its target.

To claim that these examples prove anything would be to claim far too
much; but here is what they show.
    First, "Representational Space vs. Architectural Space": Different
as the art of Leonardo, Michelangelo, and Bernini is, in it each artist
translated the difficult relation between representational and architec-

tural space into an effective instrument of his own artistic vision. In the artistic milieus of these artists there was still a vital resonance between the three primary modalities of visual expression.

Second, "Contextual Myopia": By the mid-twentieth century the pictorial sensibility had become so dominant, and with it the radical detachment of the self-contained art object from its surroundings, that the critics of Assy were all but unable to think beyond the context of such art objects. They have still to discover the difference between architectural art—art coherently related to the expressive function of its *setting* (in this case a church)—and what amounts to an all-star theme show, part of it affixed to the building and all of it on permanent display.

Third, "Expression vs. Function": When a distinguished architectural team, assuming the role of environmental planners, can seriously project the aesthetic of the roadside on the residential streets of suburbia—as if the open road and a residential neighborhood were similar modes of habitation—they are practicing pictorialism with a vengeance. Pure envisagement, the expressive function of the pictorial modality, is not only legitimate but indispensable in its proper place, but when imposed upon the architectural modality without qualification, it becomes the essence of expressive *and* utilitarian dysfunction.

Fourth, "Modernist Painting as the Beleaguered Exemplar of Visual Expression": Minimalist art, whatever we may think of it, was as sculptural as it was pictorial, and it had distinct environmental, if not architectural, implications as well. To assume that the "perspective of modernist painting" could, or indeed should, be invoked as a sufficient criterion for judging what such an art could or could not legitimately do was to defend a beleaguered, because overextended, exemplar—the pictorialization of the visual arts.

# V  THE PRECONDITIONS FOR COLLABORATION

To this point we have ignored the desperately practical problems that tend to monopolize professional discussions of architectural art— logistics, money, the courtship ritual between artist, architect, and client—not because they are unimportant but because basic theories simply are not equipped to deal with them. The proper business of the theorist is rather to examine the working assumptions of artists and architects that do not mesh; try to see how they accord with the best practice, past as well as present; and then try to make them rationally accountable to one another. An ability to ask the right questions and in the process answer them is one important, if indirect, measure of the essential soundness of a theorist's premises.

No practical issue has been debated more heatedly and inconclusively than the question, When should the artist be consulted by the architect—at the beginning of a project, before any aesthetic decisions have been made, or after the overall concept has been more or less explicitly worked out by the architect? We shall now turn to this problem. Not only does the problem itself have practical implications for the present, but also, quite unexpectedly, our analysis of it forces us to view past practices in a new light. The complaint that the artist is never consulted until the very last minute—after all the important aesthetic decisions have been made, usually to the artist's disadvantage—is often well founded, the slight crude, and the architect's rationale for it transparently self-serving. But equally questionable are the conclusions derived from this behavior. These have dominated discussions of archi-

tectural art so thoroughly that they have come to seem almost like self-evident truths: first, the artist "must" be consulted by the architect at the beginning of the project; second, that is the way it was done in the "past"; third, the unwillingness of artists and architects to work together simply testifies to the singular disaffection of "our time"; and fourth, ours is an age of individual rather than collective achievement, in which the integration of the arts, however defined, can no longer be anything more than a "pious affectation." Yet far from being either true or self-evident, these notions are all highly problematic, and their combined effect is to make the problem of architectural art seem almost hopeless. It is time they were put to the test, made to show their credentials.

To begin with, when *does* an architectural project begin? When the architect is retained by the client? When the building program has been established? When work has proceeded to the stage of rudimentary models? Simply to ask such questions is to discover how impossibly vague the ritual formula is. It could hardly be otherwise, however, for it is based on a superficial conception of the creative process. If that process were orderly, like the development of forms in a growing organism, then it might be reasonable to expect all parts of an art-and-architectural ensemble to evolve simultaneously from the first kernel of inspiration, with each part determining and being determined by all the others at each step of the way. But that is not how it typically works. Genuinely explorative creative thinking tends to be remarkably untidy—not only in the arts but in science and mathematics as well. The most the architect can do is keep clarifying the role each element in any conception is to play *as that conception evolves*, so that none of those elements ever has a chance to become too tenuous or problematic, too overdetermined or isolated from all the rest. That, of course, is the ideal to which creative workers in whatever field would probably subscribe, and its application to the present problem is clear. The architect must be able to determine when during the development of a project the artist *must* be consulted—when artistic decisions must be made that may go beyond the architect's conceptual or technical competence. Such a point may come early or late, depending upon the situation, but it is a measure of the architect's competence and integrity to recognize that moment when it does come. For the architect who cannot or will not do

so is likely to create unnecessary problems for the project as a whole, and that kind of performance is, in a word, unprofessional.

Like *beginning*, *past* is a term resonant with ambiguities. Not only can it mean almost anything that we want it to, but it also evokes images of authority, due consideration, the serious weighing of evidence—evidence we are seldom called upon to produce. But let us ask once again for particulars. What *are* the historical precedents? Almost without fail, the first, if not the only, ones to be cited are the Parthenon and the Gothic cathedrals. But surely if the collaboration between artists and architects is as necessary as is claimed, other, far more recent and more adequately documented, examples should be available in abundance. Let us seek them out in the still-considerable past that begins with Giotto and ends with the French Revolution. In order not to stack the cards, we shall confine our attention to the comparative handful of masterpieces that are almost invariably included in the standard introductory surveys of art and architecture.

In Giotto's Arena Chapel frescoes the *Last Judgment* (Fig. 61) is placed in its traditional admonitory position on the entrance wall opposite the sanctuary, where it will be the last thing the departing worshiper sees. But even in the fourteenth century contemplating man's fate was one thing and composing images to stimulate such contemplation another; certain comparatively mundane architectural considerations were still another. In this particular situation architectural considerations prescribed a large window in the upper part of the entrance wall, and Giotto had no choice but to work around it. And work around it he did—but his image is tyrannized by the scale of the window.

Since Giotto had at least one foot in the Middle Ages, however, let us move on to Masaccio, the first artist to master the principles of perspective and apply them to a wall painting. His *Holy Trinity* dates from about 1425, and for roughly a century thereafter, the greatest painters of Italy vied with one another in depicting ever more complex figure groupings in increasingly naturalistic settings. But as with Masaccio's painting, so with Piero della Francesca's *Discovery of the True Cross*, c. 1455; Leonardo da Vinci's *Last Supper*, 1495–97; and Raphael's *School of Athens*, 1510–11—all were created for existing settings. And in every case the setting contained windows, doorways, awkward

Figure 61.   Giotto, *Last Judgment*. Arena Chapel, Padua. About 1306.

viewing angles, or other features that no artist would have chosen to contend with—and which some artists began to ignore or even challenge. Thus, Raphael's subjects are perfectly related only to the architecture depicted *within* the great Vatican Stanze frescoes (Fig. 64).[1] In the Sistine Chapel (Fig. 62) Michelangelo reverts to the centuries-old tradition of systematically ornamenting the setting in which his mural is placed. But once again, the Sistine Chapel was completed in 1481 and the ceiling not begun until 1508.

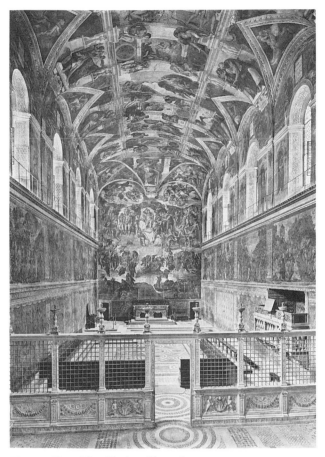

Figure 62.    The Sistine Chapel.

Figure 63.    Ugo Tognetti, The Sistine Chapel prior
to Michelangelo. Engraving. Eighteenth century.

Figure 64.    Raphael, Frescoes in the Stanza della Segnatura. Vatican Palace, Rome. 1510–11.

Since Michelangelo is perhaps the only artist in history to have excelled in painting, sculpture, and architecture, his achievement deserves a closer look in even the briefest of surveys. The only architect with whom he collaborated was himself. Functioning in his dual capacity as painter and architect, Michelangelo blocked up the windows in the end wall of the Sistine Chapel (see Fig. 62) in order to paint his *Last Judgment*, destroying at one stroke the continuity of the fenestration and two Perugino frescoes and converting what had originally been a serene High Renaissance interior into a strongly axial space culminating in the painting itself. One need only look at an engraving of the original Sistine Chapel setting (Fig. 63) to appreciate the radical effect of this alteration. Elsewhere Michelangelo was plagued by changed plans. The *Pietà* in St. Peter's was commissioned for the tomb of a cardinal that for some reason was never completed. The *David* was originally intended to adorn a buttress on the Duomo in Florence. Scholars have speculated that the *Bruges Madonna* was originally intended for the altar in Siena. Michelangelo was forced to incorporate the *Moses*, the so-called *Slaves*, and other figures intended for the Julius tomb into one abortive

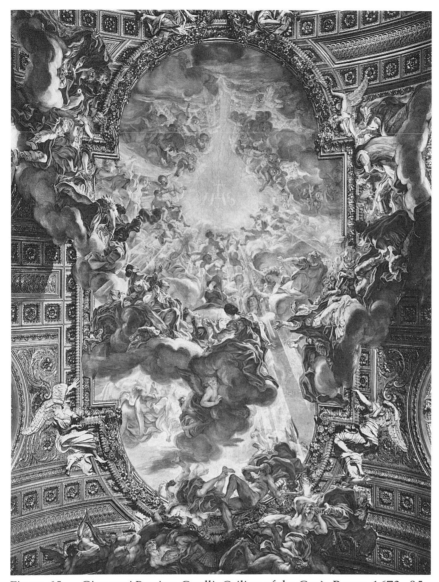

Figure 65.    Giovanni Battista Gaulli, Ceiling of the Gesù, Rome. 1672–85.

composition after another as the tomb was gradually scaled down from a huge freestanding monument with forty figures to a comparatively modest wall piece with just seven. And most of his architecture either radically modified work begun by others or was itself completed by successors, with modifications. In the case of St. Peter's it was both.

Only when we come to the baroque period do we finally begin to see anything resembling a systematic mutual accommodation between art

and architecture comparable to that of the twelfth and thirteenth centuries. Yet even then it is not necessarily a product of direct collaboration between artist and architect. Gaulli's ceiling for the church of the Gesù (Fig. 65), for example, which is generally accepted as one of the triumphs of baroque decoration, was not begun until more than a century after the church was designed. With Bernini's Cornaro Chapel (see Fig. 56), artist and architect are one and the same. Only when baroque architecture, shading over into rococo, becomes picturesque itself can one point to anything like a full-fledged collaboration, a tradition of simultaneous building and decorating—particularly in the southern part of Germany.

And it is there, finally, in the eighteenth century that we find the brothers Asam, the one a painter and decorator and the other a sculptor, who generally worked together almost like medieval artisans on such projects as the Benedictine monastery church of Weltenburg. According to Pevsner, they were "not considered as anything but competent craftsmen" and did not consider "themselves as anything else either. . . . They were brought up in villages to know something about building, and that was enough. No big ideas about professional status entered their heads."[2] One of the most famous creations of the German late baroque is the Kaisersaal of the Bishop's Palace in Würzburg, which was designed by Balthasar Neumann and painted by Tiepolo. Neumann was one of the greatest architects of the eighteenth century and Tiepolo is generally reckoned as its greatest decorative painter. But here again, the palace was completed in 1744 and the ceiling not painted until 1751. And Neumann's masterpiece, the great pilgrimage church of Vierzehnheiligen, was not completed until 1772, almost twenty years after the architect's death. But by that time Tiepolo was also dead, the Gothic revivalists were squaring off against the neoclassicists, and the French Revolution was just around the corner.

To repeat, these are crowning achievements. If these works seem to have been chosen selectively to prove a case, let anyone try to match them with an equally impressive roster of works that prove otherwise. The more seriously one studies the real, as distinguished from the fantasized, past, the more one realizes why it yields so little evidence of the kind of collaboration between artists and architects that is now deemed crucial. First, many of the most important projects were conceived on a

scale so grand that their completion was a matter not of years but of decades or even generations. During such spans of time death would take its normal toll on artists, architects, and patrons alike, even as styles changed and plagues, wars, and court intrigues conspired to change the form and meaning of what was being created. The real history of architecture is a history of structures that were never completed; or were torn down, burnt down, or fell down; or were altered, sometimes almost beyond recognition. As James Ackerman notes, "The successive architects of St. Peter's, while they held Bramante in reverence, never made the least attempt to carry out what he would have wanted."[3] Second, the art of the past was not only hostage to such developments but occasionally the direct or indirect cause of them. In the actual past the insistence on "a creative give-and-take between the artist and architect from the beginning of the project" would have sounded positively quaint, not to say naive or surrealistic. The beginning for any particular artist or architect was rarely a beginning in the biblical sense. Rather, it was the moment when his particular services were engaged.

This brings us to the third assumption, that our difficulties are due to the singular disaffection of the contemporary world. Haunted by the seeming inability of our most serious art and the most potent ideologies of our time to engage one another or to command more than a fleeting and factional assent, we take for granted that the great monumental art of the past was the product of universally agreed upon ends. There is a scale and grandeur in those time-honored works. They seem to be the product of some unanimous avowal by a populace that inspired and applauded every effort. Yet when we trouble to seek out the voices of the past, we discover a language not of timeless verities but of anguish and ambition, toil and controversy, that sounds surprisingly like our own. Here, for example, are the words of an Egyptian scribe of the New Kingdom: "I have seen the metalworker at his task at the mouth of his furnace with fingers like a crocodile's. He stank worse than fishspawn. Every workman who holds a chisel suffers more than the men who hack the ground; wood is his field and the chisel his mattock. . . . The stonecutter seeks work in every hard stone; when he has done the great part of his labor his arms are exhausted, he is tired out."[4] That backbreaking labor was always backbreaking labor, whether inspired

by faith or the lash, ought to be obvious. What is less easily accepted, however, is that even the faith was not always unalloyed. More than a generation before the Parthenon was built, the Ionian philosopher Xenophanes had observed, in a comment worthy of Voltaire, that "if the ox could paint a picture, his god would look like an ox."[5] And St. Bernard, writing in the very springtime of the great cathedral-building age, ruefully concedes that the bishops have an excuse for building elaborately ornamented churches which his brother monks do not: "Unable to excite the devotion of the carnal folk by spiritual things," they do so by elaborate show. Hence,

> the church is resplendent in her walls, beggarly in her poor; she clothes her stones in gold, and leaves her sons naked; the rich man's eye is fed at the expense of the indigent. The curious find delight here, yet the needy find no relief. Do we not revere at least the images of the Saints, which swarm even in the inlaid pavement whereon we tread? Men spit oftentimes in an Angel's face. . . . if he spare not these sacred images, why not even the fair colors? Why dost thou make so fair that which will soon be made so foul. . . . For God's sake, if men are not ashamed of these follies, why at least do they not shrink from the expense?[6]

Nor is the voice of the individual artist any more reassuring when it begins to be heard. We know, for example, that Michelangelo did everything that he could to get out of painting the Sistine ceiling, even fleeing Rome in a rage of fear and disgust with his impetuous patron Julius II. While in exile, he began a sonnet with these lines:

> Here helms and swords are made of chalices:
> The blood of Christ is sold so much the quart:
> His cross and thorns are spears and shields; and short
> Must be the time ere even His patience cease.

He signed it "Vostro Michelagniolo, in Turchia," an ironic reference to his having considered even going to work for the sultan in Constantinople.[7] In all periods of which we have sufficient knowledge, we find a panoply of contending ideals, traditions, temperaments, and complaints—complaints that, ringing down through the centuries, easily match anything that has been said in our own time. It would seem to follow that whatever else architectural art may be, it is not necessarily an instant barometer of the Zeitgeist.

The fourth and final assumption, that ours is an age of individual

rather than collective creation, turns out on examination to be little more than the other side of the same coin—the golden-age fallacy stood on its head. For there is ample evidence that the artist's sense of individuality is nothing new under the sun. As the Wittkowers remind us, "Even as early as the sixth century B.C., during the Archaic period, signatures of artists appear on statues and vases. . . . The fifth century B.C., the classical period in Greek art, saw the rise of a diversified literature by artists on art."[8] In the early twelfth century of our own era the sculptor Gislebertus affixed his name in bold letters to the great tympanum over the entrance to the Cathedral of Autun. In the early fourteenth century Dante noted that "Cimabue thought to hold the field in painting, and now Giotto has the cry."[9] And if, in contrast, our age is so overwhelmingly individualistic, how can it sustain all the performing arts, in which collaboration is an absolute necessity? How can it have given birth to an art form like jazz, in which the best musicians have been able to function as composers, performers, accompanists, and arrangers—to command the whole gamut of relations to what is nothing if not a collective creation? Are we supposed to believe that if everything cannot be integrated (however we choose to interpret that term), nothing can? That the only possible alternative to a seamless social fabric is the molecular milling of mutually antagonistic individuals? The notion is so absurd on its face that it would hardly deserve our attention if it did not tend to function like a self-fulfilling prophecy.

So much, then, for the myth of collaboration. For at root, the word itself means nothing more nor less than "co-laboring," or working together. Effective working relations tend to be the product of similar training or a long and highly developed experience of actually working together—usually both. Hans Sedlmayr once called attention to the dominance in the history of art, from the Middle Ages until the nineteenth century, of what he called a series of master problems[10]— the building of churches and town halls, castles and palaces, theaters, museums, and public monuments—which provided the visual arts with the opportunity to perfect, cumulatively over a long period, the solutions to complex problems of architectural art. When objectives become thus clearly defined in whatever field of endeavor, the highest forms of collaboration seem to develop spontaneously. It ought to go

without saying that this capacity of two or more—sometimes many more—people to function together almost as *one mind* is not only one of the most efficient working relations but also one of the most profound human experiences, one that inspires awe. Little wonder that its achievement in other times and places provokes feelings of nostalgia and inadequacy. It always has.

To confront the real thing for what it is—the hard-earned reward for a long-sustained commitment of time, energy, and intelligence—is to realize why it cannot be had simply for the asking and to see, moreover, what sustains the myth: the usual shoddy search for the instant solution. But to demystify the problem of collaboration is one thing; to interpret more realistically how architectural art actually gets created is another. To do that one must be prepared to take into account not just matters of technique and style but various circumstantial factors that can and sometimes do play a decisive role in the shaping of architectural art. We turn now to that task.

# VI WORKING WITH WHAT IS THERE

Far more important than collaboration between artist and architect has been the willingness, prevalent in the past and all but lost sight of in the heat of argument, of both architects and artists to think beyond the strict confines of their own particular modes of expression. Sedlmayr's theory of master problems helps us to understand why they were able to do so. Thus the difficulties Giotto or Raphael may have confronted—whatever else they were—were not ridiculous: neither artist had to contend with an architecture that seemed designed to exclude art on principle. But it is one thing to recognize this in a general way and another to understand how artists and architects actually go about solving the problems of relating one art form to another. To that end we shall now consider in more detail a few instructive examples: first, an important medieval example that supplements what has already been said; second, Matisse; and, finally, some examples from the present.

As is generally known, the Romanesque Cathedral of Chartres was largely destroyed in 1194 in a disastrous fire that consumed much of the town as well. Salvaged from that fire and subsequently incorporated into the thirteenth-century structure were the west front of the old cathedral, with its three windows and sculptured portals, and the famous stained-glass figure of the Virgin and Child known as *La Belle Verrière*. So accustomed are we to seeing these works as part of the present cathedral that we can easily fail to appreciate the problems their reuse posed for the architect of that structure. To see how he went about solving those problems is to observe a genius at work, one of the

very greatest architectural geniuses of his or any other time, choosing between difficult alternatives and being buffeted by the worst kind of contingency.

To begin with, he must have had reason to believe that sooner or later he would be allowed to pull down the remnants of the earlier building and to erect a new west front of his own design. But that was not to be. At some point after the construction was well under way, it was decided that the old west front would have to be retained and incorporated into the new cathedral. What caused this drastic turnabout is not known; but in the year 1210, at just about the time when this crucial decision must have been made, there were civil disorders in Chartres serious enough that the king of France came to inspect the damage to church property adjacent to the cathedral site.[1] In any case, the new nave was not in exact alignment with the old west front, nor had its bays been laid out in equal subdivisions of the space between the crossing and that old west front. So the creator of one of the most brilliantly ordered structures in the history of architecture suddenly found himself confronted with a situation that must have seemed like a satanic mockery of everything he had achieved. The new rose window could be aligned with the nave inside, but it would have to be visibly off-center from the outside. The next-to-last bay at the western end of the nave would have to be narrower and the last bay, adjoining the west front, narrower still (Fig. 66). As Henderson says, "The architect's manoeuvres in the last two bays are like nothing so much as the screeching of brakes."[2]

At the same time, one cannot help wondering whether even this architect could have given us anything to compensate for the loss of those surviving twelfth-century elements. All that one can say with any degree of assurance is that the Cathedral of Chartres is what it is—the most beautiful ensemble of twelfth-century architecture, sculpture, and stained glass grafted onto the most pristine structure of the thirteenth century—for neither purely aesthetic nor purely theological reasons but most probably for a combination of reasons having little to do with either aesthetics or theology. And, a final irony, it is the architect's bold and completely unorthodox expedients that provide us with some of our clearest insights into his own priorities as an architect. To begin with, he seems not to have cared a fig about even the most transcendent

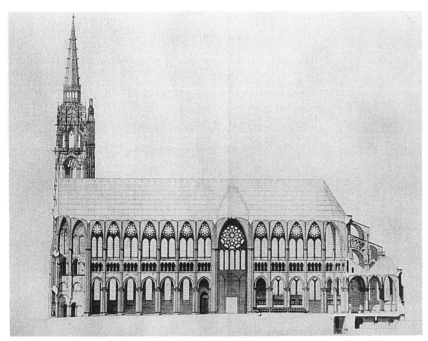

Figure 66. Chartres, sectional elevation. Avery Architectural and Fine Arts Library, Columbia University in the City of New York.

doctrinal images when these conflicted with the demands of an exalted architecture. For originally the west windows had opened not into the nave as they do now, but into the upper story of a narthex that had filled the space between the two towers. Within the confines of that space and seen more or less at eye level, these windows, devoted to the life of Christ, must have created an overwhelming effect. But confronted with the choice between restoring the narthex, thus preserving that effect, and creating a single unified interior that would be luminous in all four directions, the architect chose the latter. He pulled the floor out from under these windows, so that now they are some thirty feet above eye level—much farther from the viewer than any medallion window was ever intended to be placed. In effect, they were converted from primary didactic symbols into remote and barely decipherable pendants to the huge new rose window that he constructed above them. *La Belle Verrière* fared little better; almost as an afterthought, it appears to have been inserted into a window originally devoted to another subject.[3]

What clearly did matter to this architect was that his windows

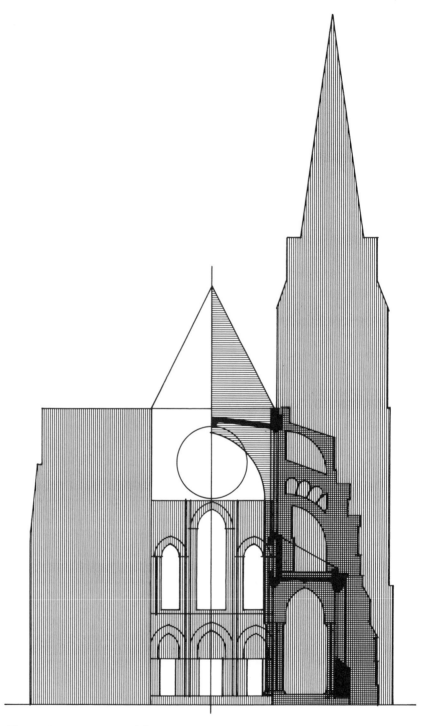

Figure 67.    Meeting of the prefire west front and the postfire nave of Chartres.

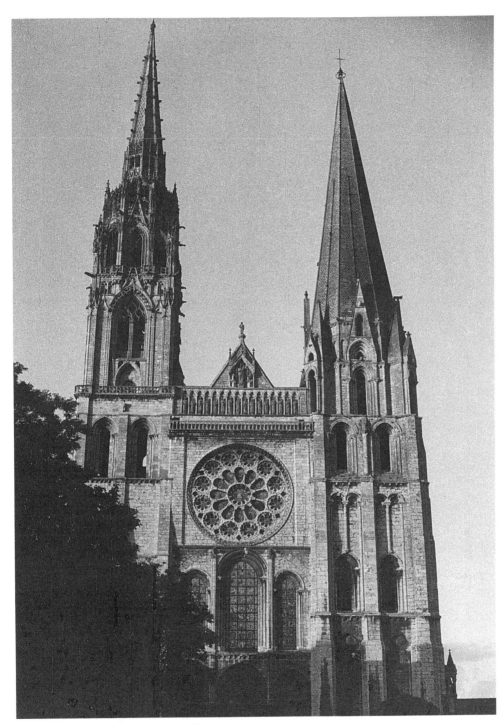

Figure 68.   The west front of Chartres.

should function as integral elements in a formal and luminous whole. Nowhere is this more dramatically apparent than in his treatment of the west rose. Between the projected height of the new vaulting (shown horizontally hatched in Fig. 67) and the remnants of the old façade (shown vertically hatched) he found himself confronted with an exceedingly awkward space—awkward not only because it was boxily horizontal but also because it would have confined the rose to about two-thirds its present size (Fig. 68). Thus (as Fig. 67 also shows) it would have been too large to read as a minor ornamental accent yet too small to function as the commanding focal point of the new façade, the element that would pull everything together. Somehow a huge rose, crowning the portals and lancet windows below, had to be shoehorned in there. And so it was—but only by means of at least one drastic expedient. As can be seen in Figure 66, the architect skewed the two westernmost bays of the vaulting and may have shortened the central, *Life of Christ*, window by two tiers to gain the necessary height.[4]

On some level at least this architect would surely have agreed with Picasso that "creation is a sum of destructions." Yet nothing could be more sensitive than the manner in which he attuned the tracery of his new rose to the sculptured portals below. With its cusped medallions, short thick colonnettes, and round-headed arches it makes a perfect bridge between the new and the old, and by any standards it is one of the most beautiful rose windows ever designed. Significant also is the handling of its glass. Traditionally, the Last Judgment had always been treated, and elsewhere was still being treated, primarily as an admonition—more a nightmarish reminder of the torments that lay in store for the damned than a preview of the eternal bliss that awaited the saved. But in Chartres the horrific implications of this age-old cautionary tale seem to have been almost deliberately sabotaged. Fire had been a recurrent reality in Chartres: the cathedral had suffered major structural damage from a fire in 1134; it had been rebuilt after a fire in 1021; there had been still another fire in 962; and the town itself had been burned by the Danes in 858 and by the Duke of Aquitania in 734. It is as if this town had finally gotten its fill of such baleful images in that one terrible night when the cathedral and town were all but consumed. For this *Last Judgment*, far from dominating the west wall as traditionally it would have done, is conceived almost purely as a decoration—so

absorbed into the ornamental geometry of the stonework, so muted in comparison with the blaze of Romanesque color below, and so far from the eye that it could never have scared a rabbit.

What do we learn from all this? That in the greatest of Gothic cathedrals there was an almost disastrous change in the building program; that the architect was dealing with formal relations that must surely have been incomprehensible to all but a tiny sophisticated elite; that the mood of the populace could shift from the joyousness of the much-celebrated episode in the twelfth century when even noblemen joined in dragging provisions to the cathedral site to the riotous anger that led to vandalism of church property; that far from being a stylistic unity the cathedral is an ad hoc assemblage of superb elements that do not quite mesh. But most important for present purposes, we learn how intensely situational the logic of genius can become when it is grounded in an unerring sense of what is essential and what is finally expendable in each of the primary modalities *in the given instance.*

It is hard to imagine that Matisse could have undertaken to paint his mural for the Barnes Foundation (Fig. 69) unless he approached that task with some sense of what is essential. For the problems posed by that commission could hardly have been more intimidating. The size, shape, and placement of the mural would have been difficulties enough. The mural space, forty-seven feet long, consisted of three nearly self-contained lunettes, almost twelve feet high, between the pendentives of the vaulting; the surface measured about five hundred square feet overall. The lunettes were joined only at the base of the mural, which was to be eighteen feet above floor level. Under each lunette was a huge window, and between the windows hung major paintings by Picasso and Matisse himself. On the other walls of the gallery were two Cézannes, a Seurat, and several Renoirs. Thus, the mural would have to be viewed not only at an awkward angle and against full daylight but also in company with several masterpieces of modern painting—and all of this front and center, in the main gallery of one of the most important collections of modern art anywhere in the world.

More than any other major twentieth-century painter, Matisse had been trained in the principles of decorative art and drawn to the grand simplifications that these made possible.[5] Thus after the mural was completed, he was able to describe what he had done, how he had done

Figure 69.    Henri Matisse, *Dance* II. By permission of the Barnes Foundation, Merion, Pennsylvania. 1932–33.

it, and why with a clarity and precision few critics could match. The only thing that seems to have been established at the outset was the theme of the dance, a subject to which Matisse had been drawn a quarter of a century earlier. His first tentative pencil sketches for the mural are derived almost directly from the large 1909 *Dance* in Moscow. But as Matisse explained to a Russian critic, that was still an easel painting, "a work which can hang anywhere,"[6] whereas "architectural painting depends absolutely on the place that has to receive it, and which it animates with a new life."[7] Alfred Barr and others have told how the design gradually evolved,[8] and the story need not be repeated here. Sufficient for present purposes are the artist's own description of the difficulties posed by this mural and how he dealt with them.

Matisse soon discovered that he was not getting anywhere with his small studies and hired an unused film studio so that he could compose the mural at full scale:

> Armed with charcoal on the end of a bamboo stick, I set out to draw the whole thing at one go. It was already there, in me, like a rhythm which carried me along. I had the surface in mind. . . . I had to be

closely allied to the masonry, so that the lines should hold their own against the enormous projecting blocks of down-curving arches, and even more important, that the lines should follow across them with sufficient vitality to accord with each other. To compare all that and obtain something alive and singing, I could only proceed by groping my way, continually modifying my panels in colours and black.[9]

Elsewhere, he referred to this project as "a struggle between the artist and fifty-two square metres of surface, of which the spirit of the artist had to take possession."[10] Years later, when asked about the difficulty of composing a mural that would have to be viewed against the light, he replied, "In the end I profited from the situation. . . . I made use of the contrast created by" the light coming through the windows: "I put blacks in the ceiling [i.e., the mural] much darker than the grey of the spaces between the doors. Thus I displaced the contrast. . . . I put it up in the ceiling so that my very strong contrast united the whole panel, doors and spaces." And he went on to say, "I could not, did not claim to, nor ought I to have fought with" the great paintings hanging in the gallery. "Above all, I had to give the impression of vastness in a limited space. That's why I used figures which are not always whole, so half of them is outside. . . . If for example, I filled a space three metres high, I would have the figures a total height which, if fully represented, would have been six metres. I use a fragment and I lead the spectator by the rhythm, I lead him to follow the movement from the fragment he sees so that he has a feeling of the totality."[11] The genius of this solution becomes apparent when the mural is reproduced as I show it here—in relation to the size and tonality of the wall it was designed to ornament.

Confronted with a setting that was both difficult and conventional, Matisse created a work that would influence the development of large-scale painting, from his own late wall-sized collages through the works of artists like Newman and Motherwell down to the present day. But generally speaking, recent architectural art has had neither a conventional nor an indoor setting. Increasingly such art has been called on to function less as an integral element of any particular building than as a part of what might be called a civic interior—a public urban space that may be either smaller or larger than any particular building and which the art itself helps to define. In Rockefeller Center, for example, there is a bronze relief by Manzù (Fig. 70) that is almost

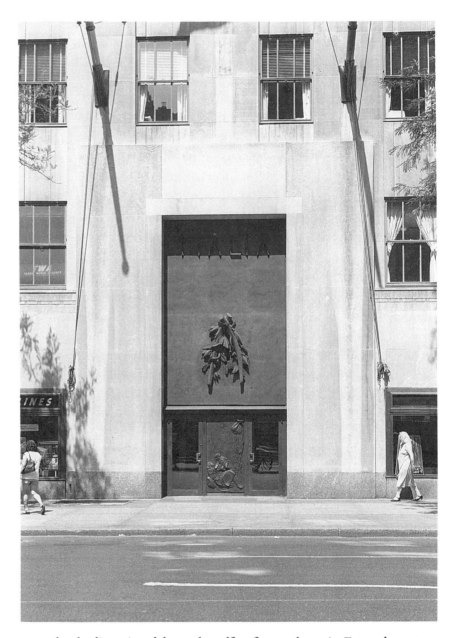

completely dissociated from the office floors above it. From the oppo-
site side of the street it reads as little more than an animated accent in
the lower center of the two-story entrance of which it *is* an important
part. Clearly, one is intended to come upon this work as upon a friend
in a chance encounter, for only at close range (Fig. 71) does the work
reveal itself in all its warmth, wit, and marvelously tactile handling.

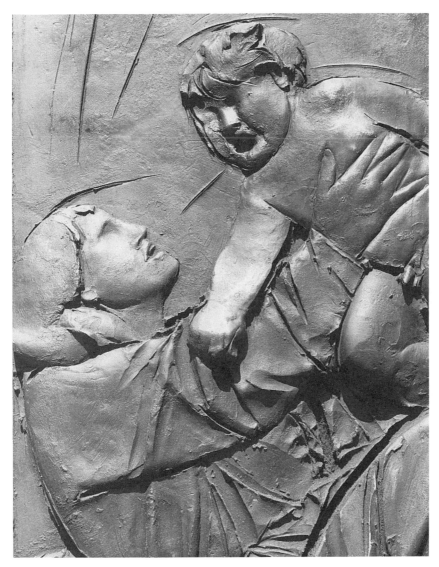

Figures 70–71.    Giacomo Manzù, *Mother and Child*. Rockefeller Center, New York.

At opposite poles from this work is the *LIU Arch* (Fig. 73), a kind of stripped-down triumphal arch designed by Quennell Rothschild Associates as an entrance to the Long Island University campus in downtown Brooklyn. Painted a cool pink, white, and tomato red, this construction, assisted by some tasteful planting, accomplishes the difficult feat of bringing to life an otherwise completely amorphous space that

Figure 72.    Richard Haas, Untitled mural. Peck Slip, New York. 1978.

Figure 73.    Quennell Rothschild Associates, *LIU Arch*. Long Island University, Brooklyn, New York. 1985.

Figure 74. Jean Dubuffet, *Group of Four Trees*. Chase Manhattan Plaza, New York. 1972.

is far *larger* than any single building. Similarly effective in defining a huge amorphous space is Dubuffet's freestanding *Group of Four Trees* (Fig. 74) in Chase Manhattan Plaza. Bold, playful, gesticulative, it emulates the rambunctious buffoonery of circus clowns to create a congenial walk-through sculptural environment. Now that it is there, the space is unimaginable without it. To compare these three works is to realize once again how unhelpful the usual technical distinctions between the visual arts are: although cast bronze is basically a sculptural medium, Manzù uses it pictorially; although metal-frame construction belongs to architecture, the *LIU Arch* works almost like the Dubuffet to lend sculptural presence to an architectural void. And whereas the Manzù is technically "integrated" with a building to most of which it bears no visual relation, the other two works are "juxtaposed" to buildings whose overall effect they vastly enhance.

Richard Haas has been quoted as saying that his architectural murals (Fig. 72) are "corrective, not collaborative," and looking at his composition on the end of a power station in Peck Slip, we can see what he means. For it is a dispassionate full-scale trompe l'oeil evocation of an architecture that "once might have been." Even more instructive, however, is the Richard Serra sculpture (Fig. 75) installed in 1981 in nearby Federal Plaza—an anything-but-elegiac work next to a building that manifestly should never have been. This sculpture, the subject of a still-unresolved controversy,[12] consists of a single wall-like plane of Cor-ten steel 12 feet high and 120 feet long that is slightly canted and bowed—hence its title, *Tilted Arc*. Federal Plaza, bounded on one side by Foley Square and on the other by Broadway, is a characterless space dominated by a single huge building of strident mediocrity. Whatever the two earlier courthouses "do to bring coherence to Foley Square this building undoes completely," Paul Goldberger observed in his guide to Manhattan architecture—published before the Serra had been installed or become an issue. He went on to describe the Federal Building as follows:

> It consists of a glass box (the court) set in front of a decorative checkerboard-skinned tower (the offices), and surely the architects are full of . . . clever theories about how well the low, separate, and more formal courthouse and the bigger, blander office area behind it are appropriate expressions of their different roles. Claptrap. . . . Discord

seems to have been consciously sought here—it is achieved so often. Not only does the courthouse wing clash with the office tower and both of them clash with the old courts across the square, but the rear section of the tower (added a few years later) clashes entirely with the front section. There are two skins used, both of them are ugly, and they fight with each other as much as they fight everything around them.[13]

If Serra is to be faulted for anything, therefore, it ought to be, first, for hubris—for thinking that *any* sculptural tail, however imposing, could wag this hulking mutt of a building.

The *Tilted Arc* was so placed as to be seen end-on (as in Figs. 75 and 76) when approached from either the street or the building's entrance, and when so seen it was quite surprisingly graceful. Immediately north of Federal Plaza is a block front of one-story shops punctuated by two refurbished loft buildings, and the amorphous plaza space finally terminates only in the block beyond, where there is a still-intact block front of old office buildings. When the Serra was viewed broadside against that background (Fig. 77), it functioned like a visual retaining wall, effectively screening out the street-level cacophony of shop fronts and automobile traffic. Only from its far side, with the Federal Building itself in the background (Fig. 78), did the wall-like expanse of the arc read as a "hostile barrier." In short, the Serra, whether you happen to like it or not, was infinitely more site-sensitive than the building it graced. And those federal bureaucrats who, having directly or indirectly countenanced the architectural defacement of New York City's principal courthouse square, banished the one redeeming element of visual intelligence from their complex succeeded only in making themselves look doubly ridiculous. It is their visual sensibilities that need to be recycled.

These examples, all drawn from the urban environment I happen to know best, are at opposite poles from what has come to be known as "environmental art," a great deal of which is placed in natural settings in which it may be the only sign of human intervention. The works most intimately related to their setting in material, technical, and formal character are those that seek to make explicit the qualities that will transform a particular location into a distinct place. Like all who are still sensitive to the immediate, physiognomic aspects of the

Figures 75–78.    Richard Serra, *Tilted Arc*. Federal Plaza, New York.
1981.

Figure 79.    Michael Singer, *First Gate Ritual Series 7/79*. Oak, phragmites, rocks, jute rope, and spruce branches. Wilmington, Vermont. 1979.

natural environment, Michael Singer builds his strangely evocative wooden structures (Fig. 79), as he puts it, "to see more of what I am, where I am."[14] His slender strips of sparingly shaped, bent, and inter-woven wood seem intended to establish a link between human con-structions and those of the various animal nest builders—a link that serves to make all the more eloquent the distinctively human, modu-lar, frontal, and proto-ritualistic elements evident in his work. Simi-larly, the work of Alice Aycock, Robert Morris, and Siah Armajani is insistently preoccupied with orientation, enclosure, vulnerability, confinement—that is to say, with some of the most fundamental ele-ments of the architectural modality.[15]

Far less intimately related to their natural setting are such works as Michael Heizer's *Complex One/City* (Fig. 80), a cement, steel, and earth construction measuring 24 by 110 by 140 feet that took four

years to build; Robert Smithson's *Spiral Jetty*, 1500 feet long, for which Smithson had to move 650 tons of earth and rock; and Walter De Maria's *Lightning Field*, 400 stainless steel poles 20 feet high, spaced precisely 200 feet apart in a grid measuring one mile by one kilometer. In all these works modern technology is employed to create minimal, gestural, or process art on a scale heretofore reserved for communal monuments. Whereas creations of such size once presupposed the massive commitment of human and animal energies for periods of time measurable in generations, they now entail nothing more than the wherewithal to commit advanced earth-working technology to the imperatives of self-expression. Since the gains for self-expression are so obvious, it is worth pausing to consider some of the limitations or pitfalls as well, evident in what is perhaps the most ambitious of these projects, Heizer's *Complex One*.

In commenting on this work, which I have not actually seen, I shall rely on what can be gleaned from photographs; the observations of Elizabeth C. Baker, editor of *Art in America*, who has seen the work in situ; and statements by the artist. As Baker describes the work, it is a sophisticated medley of pictorial, sculptural, and architectural elements variously affected by the distance, angle of view, and light conditions under which it is seen. From about half a mile away it "is essentially pictorial, a big, apparently two-dimensional rectangle, its 'picture' shape and proportions reinforced by the frame; in the middle distance, it is perceived as a solid, buildinglike form with the various frame or columnar elements reading like beams, walls or other structural members; close up, the parts interact sculpturally with one another and with the viewer in a 'normal' sculptural way."

It is apparent, however, even from the photograph accompanying Baker's article, which was taken absolutely front and center from a considerable distance, that the two-dimensional or pictorial element in this work keeps threatening to break down into its more basic sculptural components. As the lighting in that photograph makes clear, the right-hand end of the structure slants back from that illusory upright "picture plane." Indeed, were it not for the visual dissonance created by such sculptural torsion, it is hard to see how that long flat rectangular shape could command attention. Nor for that matter could the architectural allusions of the work that Baker calls to our attention: "the

Figure 80.    Michael Heizer, *Complex One/City*. South-central Nevada. 1972–76.

Egyptian mastaba for the general form and the snake bands bordering the ball court at Chichén Itzá for the framing members," the false-front buildings of the gold-rush towns, the overall rectilinear massing of the work itself. All are relevant and recognizable as far as they go, but they go only skin deep. Despite the urban connotations of the work's full title, *Complex One/City*, it is essentially a sculptural crea-tion. No human or humanly inspired activity is visibly presupposed, no mode of habitation even embryonically defined. One is left with what Baker describes as "the integration-distintegration-reintegration of parts in space, the assured fusion of painting, sculptural, and archi-tectural ideas" of "an artist confidently manipulating what he knows about contemporary art."[16]

Only when we discover what Heizer has said about this work—not, apparently, to Baker—do we begin to grasp his intentions: "When that final blast comes, a work like *Complex One* will be your artifact. It's going to represent you. *Complex One* is designed to deflect enor-mous heat and enormous shock. It's very much about the atomic age."[17] So there we have it: *Complex One* is intended to be a kind of postnuclear City of the Dead, a monument to that one fateful action that threatens to render the planet uninhabitable—turn it into a dead cinder on which the very notion of a monument will have been forever

Figure 81.    Abandoned ABM installation near Grand Forks, North Dakota. 1975.

obliterated. But even by the most Strangelovian standards this work fails to measure up. For in presenting it as such, Heizer invites comparison between his own creation and the effect generated by modern earth-working technology when it is committed on a communal scale to producing the actual instruments of a thermonuclear holocaust. Consider, for example, the abandoned $5.7 billion ABM site near Grand Forks, North Dakota (Fig. 81). Here is the architecture of death, naked of any archaeological allusions yet fully articulated and generating its own most fearsome images. As Ada Louise Huxtable observes, "it is without doubt one of the most peculiarly impressive built groups of our time. Architects trying consciously for impact and meaning might just as well call it quits in the face of this kind of brute esthetic force."[18]

This brings us finally to an artist like Robert Irwin, who would go a step beyond any of these environmental artists. For whereas any work by Nancy Holt or Michael Singer is likely to be recognizable as such, Irwin's intention is to create environmental art that is as nearly determined by its site as possible:

> Here the sculptural response draws all of its cues . . . from its surroundings. This requires the process *to begin* with an intimate, hands-on reading of the site. This means sitting, watching, and walking

through the site, the surrounding areas (where you will enter from and exit to), the city at large or the countryside. . . . are we dealing with New York verticals or big sky Montana? What kinds of natural events affect the site—snow, wind, sun angles, sunrise, water, etc.? What is the physical and people density? the sound and visual density (quiet, next-to-quiet, or busy)? What are the qualities of surface, sound, movement, light, etc.? What are the qualities of detail, levels of finish, craft? What are the histories of prior and current uses, present desires, etc.? A quiet distillation of all this—while directly experiencing the site—determines all the facets of the "sculptural response" . . . whether the response should be monumental or ephemeral, aggressive or gentle, useful or useless, sculptural, architectural, or simply the planting of a tree, or maybe even nothing at all.[19]

Everything is open to question. As far as possible the artist's creation is a considered response to what is already significantly there.

If we may venture to generalize from these examples, what is already there may be an incomplete or unresolved assemblage of art and architectural elements (as in Chartres and the Barnes Foundation), a more or less coherent urban space created by the circumstantial grouping of existing structures and thoroughfares (as in Chase Manhattan Plaza and Peck Slip), or a completely undeveloped, architecturally neutral setting (like those employed by Singer or Heizer). Whichever it happens to be, the artist may find compelling reasons in the particular case to (1) create a major unifying element for the whole (like Matisse and Dubuffet) or (2) make a distinct subwhole that complements the whole (like Manzù and Singer). In either case the artist may (3) exploit certain given material, iconographic, or other site-specific elements (Matisse, Haas) or (4) exploit some and transform or reject others (the architect of Chartres, Serra). But it should be obvious that *whatever* the artist does affects, and is affected in various recognizable ways by, whatever is already there.

# CONCLUSION

The effort to understand the visual arts as autonomous, archetypal, self-defining entities, each standing in magnificent isolation from the others, is epitomized by Clement Greenberg's interpretation of Modernist painting.[1] But the real world of modern art (modern with a small m, and in its prime) was nothing like that. Rather, it was a world in which the painting of Matisse could be lastingly influenced by Moorish ornamentation and that of Picasso by African masks; a world in which both artists could use sculpture to clarify aspects of their painting. For these artists the differences between the visual arts evidently were instructive—not contaminating. At about the same time, Mondrian and his colleagues in the De Stijl group, which included the sculptor Georges Vantongerloo and the architect J. P. Oud, could posit rectangular forms and the primary colors plus black and white as a sufficient alphabet of elements for all the visual arts. These artists, the most thoroughgoing purists of their time, recognized that on some level painting, sculpture, and architecture speak a *common* language. And elsewhere William James, who died in 1910, could write a devastating analysis of the Kantian thinking in discontinuous terms that Greenberg would proclaim as Modernist some forty or fifty years later—thinking that "draws the dynamic continuity out of nature as you draw the thread out of a string of beads."[2]

I have proposed that instead of viewing painting, sculpture, and architecture as distinct "things" of any kind, we treat the pictorial, the sculptural, and the architectural essentially as activities—the basic forms of visual expression employed to *create* such distinct things as paintings, statues, and buildings. Instead of beginning with the mate-

rial, technical, stylistic, or symbolic attributes of the visual arts—none of which is the exclusive property of any particular art form—I ask, What are the most singular expressive aptitudes of these basic forms of visual expression? What does each one do that the others can be made to do only with difficulty, if at all? The answers to these questions, however tentative and open-ended they may be, provide us with working definitions of the primary modalities of visual expression. Just as our working definitions of the primary colors are finally conceptions—not this or that physical color sample per se but the purest conceivable red, yellow, or blue—so our working definitions of the basic forms of visual expression can only be conceptions of whatever we take to be most distinctively pictorial, sculptural, or architectural.

To accept them as such is to accept the world of visual art as we actually experience it—as a world in which the arts meet, merge with, and mutually reinforce or swear at one another, often in unexpected yet compelling ways. It is to recognize what has so long been obscured by the distinction between fine and applied art: that each of the basic forms of visual expression is endowed with its own unique *expressive* function. It is to realize that even the most defiantly useless piece of art-for-art's-sake art must perform some expressive function in order to be recognizable as art at all; that the Persian carpet on a collector's floor may well be finer than the latest acquisition hanging on his wall; and that no amount of mechanical utility by itself can define a mode of habitation worthy of the name architecture. It is to accept the visual arts as indeed visual *arts*—not just incarnate approximations of what can be said about them in so many well-chosen words.[3] It is also to realize, by analogy with the color circle, that the domain of the three primary modalities can be amplified by polar variables—similar to tonal value and hue saturation—that not only transcend the parochial distinctions between materials, techniques, and styles but vastly extend the range of possible combinations of the primary modalities. And finally, it is to define the basic forms of visual expression systematically, by comparison and contrast with one another, within the realm of visual expression as a *structured whole*.

As nearly as any theory can, therefore, this one equips us to recognize when the basic forms of visual expression are conceptually confused with one another. Thus when Reyner Banham purports to define

architecture, however loosely, as "functionally, the creation of fit environments for human activities, aesthetically, the creation of sculpture big enough to walk about inside,"[4] we balk. For Banham not only scrambles the differences between two basic arts but in the process deprives architecture of its own expressive rationale. As we saw earlier, Dubuffet's *Group of Four Trees* (see Fig. 74) is big enough to walk about inside, but we recognize it as sculpture, not architecture: it defines no mode of habitation. And we recognize Le Corbusier's chapel in Ronchamp (see Fig. 13) as architecture, not walk-in sculpture, even though it contains sculptural form, for that form is employed not to create an autonomous sculptural presence but to achieve an elemental organic monumentality that could not have been achieved with the rectilinear machine-like elements of International Style architecture. As it happens, Banham's definition is almost exactly contemporary with Eero Saarinen's ineffectually sculpturized airline terminal (see Fig. 12) —a far-from-academic example of the same gratuitous confusion of genres.

Let us assume, then, that we have indeed staked out the rudiments of a more coherent theory of the relation between the visual arts and have shown some of the ways in which our balkanized conception of those arts is wanting. How do we get from my cautiously comparative generalizations about the primary modalities of visual expression to the specific qualities that finally distinguish one visual art medium from another? Perhaps the best way to begin answering this question—and that is all I shall pretend to do here—is to refer the reader back to chapter 3 and my own analysis of the art of stained glass. Rather than assume at the outset that this art must be "either" a form of painting "or" a mere ornamental adjunct to architecture, I began by defining it historically in a general way as an art that combines some qualities of both painting and architecture and oscillates between the pictorial and architectural modalities. That proposition, first, begged no major categorical questions and, second, positively invited further, increasingly more specific, questions about the distinguishing attributes of *this* art: What qualities does it share, or has it at some time manifestly shared, with painting? What qualities with architecture? Then, as the answers to those questions began to fall in place, How have its pictorial and architectural qualities been affected by the successive changes in major period styles?

By important individual styles? And so on.

To proceed in that way was to find myself discovering just how the singular qualities and technical constraints of stained glass finally do distinguish it from both painting and architecture. From my initial abstract positioning of this art in the realm of visual expression to the end of the analysis, I was able to progress not just toward concreteness for its own sake but toward a demonstrably fundamental concreteness. To be sure, I had long known much of this from my own experience working with stained glass. But it is one thing to learn the basic workings of a particular art form from the inside, more or less viscerally, and quite another to convey that information to others in a reasonably coherent way. And that is what the theory of primary modalities finally enabled me to do.

To say any more about the subject would be to say a great deal more and to write another kind of book. But surely we have come far enough in this one to confirm the intuition with which it began: it *is* possible to construe the visual arts as an intelligible whole; our tortured patchwork conceptions of them *are* our own, not inherent in the arts themselves.

# NOTES

*PART ONE: On the Realm of Visual Expression*

1. George Kubler, *The Shape of Time* (New Haven, Conn., 1962), p. 15.

2. Clement Greenberg, "Modernist Painting," in *The New Art*, ed. Gregory Battcock (New York, 1966), pp. 102–4.

3. Ibid., p. 107.

4. For an architectural version of the technological myth of Modernism, see Siegfried Giedion, *Space, Time, and Architecture*, 3d ed. (Cambridge, Mass., 1954). As Vincent Scully has observed, Giedion's book gave modern architects

> what they wanted: a strong technological determinism. . . . myths and martyrs, and a new past all their own. It presented them with an historical mirror, so adjusted as to reflect only their own image in its glass. What they did not want to be told was that they were working in a style. . . . *Space, Time and Architecture* brilliantly avoided the difficulty . . . by producing instead a formula, that is, "Space-Time." This cabalistic conjunction . . . had . . . at once a spurious relation to science and a certain incomprehensibility except in terms of faith. Like all the best slogans it could mean anything because, even as one shouted it, one might entertain the comfortable suspicion that it need not, in fact, mean anything at all.

See Scully's "Modern Architecture: Toward a Redefinition of Style," in *Reflections on Art*, ed. Susanne K. Langer (Baltimore, Md., 1958), pp. 342–43.

5. Henri Focillon, *The Life of Forms in Art*, rev. ed. (New York, 1948), p. 34.

6. Sidney Geist, *Brancusi* (New York, 1968), p. 161; Geist's italics.

7. Nelson Goodman, "How Buildings Mean," *Critical Inquiry* (June 1985), pp. 646–47. For a more extensive definition of metaphorical exemplification, see his *Languages of Art* (Indianapolis, Ind., 1976), chapter 2.

8. Rudolf Arnheim, *Art and Visual Perception*, rev. ed. (Berkeley, Calif., 1974), pp. 444–45; Arnheim's italics.

9. That the arts cannot be categorized as things or adequately defined in terms of their materials, techniques, or styles has long been recognized by some. See, for example, John Dewey, *Art as Experience* (1934; New York, 1980, p. 162; Dewey's italics): "There is a difference between the art product (statue, painting or whatever), and the *work* of art. The first is physical and potential; the latter is active and experienced. It is what the product does, its working." Susanne K. Langer, *Feeling and Form* (New York, 1953, p. 102): "Having a material in common does not link two arts in any important way." Harold Rosenberg, "Art and Words," 1969 (in *The De-definition of Art*, New York, 1972, p. 64): "The notion that a new way of using materials can be inherently significant and even progressive is another instance of the overpower-

ing of the eye by words." Rudolf Arnheim, "Style as a Gestalt Problem," 1981 (in *New Essays on the Psychology of Art*, Berkeley, 1986, p. 268): "A style rubric like Classicism or Fauvism is not a sorting box for a group of works or artists thought to belong in this container rather than another. It is the name for a way of making art, defined by a particular use of the medium, the subject matter, etc. Such a style can be traced and isolated as a component in the work of one artist or several, in one period or place or several, and it can show up as dominant or secondary, persistent or temporary."

## I. The Primary Modalities

1. How to categorize the cinema, for example? Claiming it for either the visual arts or the performing arts alone does violence to it. As we have already seen, the question of the art to which any material or technique really belongs puts the physicalist cart before the expressive horse. From a purely expressive point of view the newsprint in a cubist collage belongs to that collage—not to *Le Figaro.* I would submit that the various techniques employed in moviemaking belong with equal force wherever they perform a valid expressive function. The distinction between art and nonart is similar. As Nelson Goodman puts it, "a piece of bronze may be a work of art and a bludgeon; a canvas may be a Rembrandt masterpiece and a blanket. . . . While no bludgeon is a Rodin and no blanket is a Rembrandt, the same physical object may batter or warm in some contexts and perform the symbolic functions of a work of art in others. As I have suggested elsewhere, we may need to turn our attention from the question 'What is art?' to the question 'When is art?' (*Of Mind and Other Matters* [Cambridge, Mass., 1984], p. 142). In any case, our concern here is with the core phenomena of visual expression: first things first.

2. Susanne K. Langer, *Feeling and Form* (New York, 1953), p. 88.

3. Vincent Scully, *American Architecture and Urbanism* (New York, 1966), pp. 199–200.

4. Arthur C. Danto, *The Philosophical Disenfranchisement of Art* (New York, 1986), pp. 32–35.

## II. Polar Variables

1. Rudolf Arnheim, *The Dynamics of Architectural Form* (Berkeley, Calif., 1977), p. 164.

2. Langer, *Feeling and Form* (New York, 1953), pp. 101–2; Langer's italics.

3. Arnheim, *The Dynamics of Architectural Form*, p. 128.

4. Peter Blake, *The Master Builders* (New York, 1961), p. 195.

5. Juan Pablo Bonta, *Architecture and Its Interpretation* (New York, 1979), p. 151. Bonta's analysis of the Barcelona Pavilion from its inception to

its eventual canonization by architectural critics and historians, pp. 131–83 and 202–17, is an exemplary study not only of a major architectural monument but also of the dynamics of its critical interpretation.

6. Kenneth Clark, *Rembrandt and the Italian Renaissance* (New York, 1966), pp. 90, 100.

7. Similarly, sculpture may *convey* the qualities of clear or diffused light independent of the light in which it happens to be exhibited. For as Charles Seymour, Jr., has noted, "Simple contours and smooth compact surfaces define light as broad and calm and the atmosphere around them as heavy and quiescent. Deeply undercut and irregular forms on the other hand, tend to define light as a flickering movement and the atmosphere as a restless force searching like a fluid to penetrate matter, to enter through crevices and crannies the very stone or bronze itself" (*Tradition and Experiment in Modern Sculpture* [Washington, D.C., 1949], p. 11).

8. For more on this effect, see Robert Sowers, *The Language of Stained Glass* (Forest Grove, Oreg., 1981), chapters 2 and 3.

9. Louis I. Kahn, "The Room, the Street, and Human Agreement," *Arts in Society* (Spring–Summer 1972), p. 110, and *Light Is the Theme* (Fort Worth, Tex., 1975), p. 12.

10. Quoted in Alexandra Tyng, *Beginnings: Louis I. Kahn's Philosophy of Architecture* (New York, 1984), p. 162.

### III. Stained Glass: Painting with Structure and Light

1. Quoted in John Lobell, *Between Silence and Light: Spirit in the Architecture of Louis I. Kahn* (Boulder, Colo., 1979), p. 34; and Kahn, "The Room, the Street, and Human Agreement," *Arts in Society* (Spring–Summer 1972), p. 110.

2. See Robert Sowers, *The Language of Stained Glass* (Forest Grove, Oreg., 1981), chapter 8.

3. To view ornament as, at best, extraneous embellishment is to impoverish our understanding not only of primitive, medieval, and oriental art but also of the vital role that the principles of ornamental order have played in our own supposedly nonornamental art, from the Renaissance to the present. As David Summers observes in *Michelangelo and the Language of Art* (Princeton, N.J., 1981), p. 90,

> We have lost—or rejected—the language for taking it [ornament] seriously. In this respect ours is different from the tradition that nourished Michelangelo, and however much we might like to find our taste borne out in the greatest examples of Renaissance art, we shall not be able to understand its intentions or the real nature of its accomplishments . . . if we are not willing to suspend our distaste for ornament. To take an example, the greatness of the Sistine Ceiling is not lessened by the degree to which, in Renaissance terms, it was consciously and overwhelmingly ornamental. . . . Ornament works, and its

workings must be understood if we are to appreciate the conscious steps that lead to great artistic accomplishment.

And as Thomas H. Beeby demonstrates in "The Grammar of Ornament/ Ornament as Grammar," *VIA* (1977), Sullivan, Wright, Mies, and Le Corbusier, the founders of modern architecture, all thoroughly understood and exploited the workings of ornament in their plans, sections, and elevations. Beeby documents his argument with example after example and concludes that "the architect raised on the intricacies of ornament had a grammar of form which has been denied those trained in Modernism." And when we examine the basic principles of that grammar—repetition, rotation, reflection, and inversion—we find that they are the very same ones now being exploited once again in what has come to be called serial order. As Mel Bochner properly insists in "The Serial Attitude," *Artforum* (December 1977), this order is a method, not a style—a method observable not only in the cerebral constructions of Sol LeWitt but also in some of Andy Warhol's most compelling multiple-image silk-screened paintings. Especially effective, for example, are the mirror-image reversals in *Jackie (The Week That Was)*, of 1963.

4. As quoted by Ed Carpenter, "Windows, Walls: Structural Dialogue Between Equals," *Smithsonian* (February 1978), p. 86.

5. H. W. Janson, with Samuel Caumon, *A Basic History of Art* (New York, 1971), pp. 330–31.

6. William Rubin, *Modern Sacred Art and the Church of Assy* (New York, 1961), p. 93.

*IV. Pictorializing the Visual Arts*

1. Kenneth Clark, *Leonardo da Vinci*, rev. ed. (Baltimore, Md., 1958), p. 67.

2. Ibid., pp. 89–97.

3. E. H. Gombrich, *The Story of Art*, 12th ed. (London, 1972), p. 225.

4. Leo Steinberg, "Leonardo's *Last Supper*," *Art Quarterly* (Winter 1973), pp. 297–410.

5. Ibid., p. 354.

6. Ibid., pp. 358, 370.

7. Ibid., pp. 343, 349.

8. Gombrich, *The Story of Art*, p. 233.

9. William Rubin, *Modern Sacred Art and the Church of Assy* (New York, 1961), p. 167.

10. Thomas F. Mathews, S. J., "The Problem of Religious Content in Contemporary Art," *Revolution, Place, and Symbol: Journal of the First International Conference on Religion, Architecture, and the Visual Arts* (New York, 1969), p. 119.

11. Fernand Léger, "Painting and Reality," *Daedalus* (Winter 1960), p. 88.

12. Rubin, *Modern Sacred Art*, pp. 126–27.

13. John Dillenberger, "Artists and Church Commissions: Rubin's Church of Assy Revisited," *Art Criticism* (Spring 1979), p. 81.

14. Robert Venturi, Denise Scott Brown, and Steven Izenour, *Learning from Las Vegas*, rev. ed. (Cambridge, 1977).

15. Robert Venturi, *Complexity and Contradiction in Architecture* (New York, 1966).

16. Venturi et al., *Learning from Las Vegas*, pp. 128–31.

17. Ibid., pp. 101, 103.

18. Ibid., p. 87.

19. Ibid., p. 139.

20. Ibid., pp. 153–54.

21. Michael Fried, "Art and Objecthood," in *Aesthetics Today*, ed. Morris Philipson and Paul J. Gudel, rev. ed. (New York, 1980), pp. 219, 232.

22. Vincent Scully, *The Earth, the Temple, and the Gods*, rev. ed. (New York, 1969).

23. Rudolf Arnheim, *Art and Visual Perception*, rev. ed. (Berkeley, Calif., 1974), p. 378. How the major orders of artistic expression are related to one another is a fundamental problem of aesthetics, not just a topsy-turveydom of Diabolical Others. See, for example, Susanne K. Langer, *Feeling and Form* (New York, 1953), and Nelson Goodman, *Languages of Art* (Indianapolis, Ind., 1976).

24. Fried, "Art and Objecthood," p. 230. On the ideology of absolute genre distinctions, see W. J. T. Mitchell, *Iconology: Image, Text, Ideology* (Chicago, 1986), especially chapter 4. For a narrow straw-man definition of sculpture as a pedestaled art form, typified by the equestrian statue of Marcus Aurelius in the Campidoglio, see Rosalind E. Krauss, "Sculpture in the Expanded Field," in *The Originality of the Avant-Garde and Other Modernist Myths* (Cambridge, Mass., 1985), pp. 277–80. So much for everything else we always thought was sculpture, from the Venus of Willendorf to Anthony Caro!

## V. The Preconditions for Collaboration

1. In the *School of Athens*, for example, Raphael depicted a vast architectural space far more impressive than the Stanze in which the mural is situated; and as A. C. Sewter notes, the foreground figures in the adjacent *Parnassus* "appear to lean on the frame of the window, and actually to project into the room" (*Painting and Architecture in Renaissance and Modern Times* [London, 1952], p. 7).

2. Nikolaus Pevsner, *An Outline of European Architecture* (Baltimore, 1963), p. 263.

3. James S. Ackerman, "Architectural Practice in the Italian Renaissance," in *Renaissance Art*, ed. Creighton Gilbert (New York, 1970), p. 170.

4. V. Gordon Childe, *Man Makes Himself* (New York, 1951), p. 149.

5. E. R. Dodds, *The Greeks and the Irrational* (Berkeley, Calif., 1951), p. 181.

6. G. G. Coulton, *Art and the Reformation* (Oxford, 1928), appendix 26.

7. J. A. Symonds, *The Life of Michelangelo* (New York, n.d.) p. 116.

8. Rudolf Wittkower and Margot Wittkower, *Born under Saturn* (New York, 1969), pp. 2–3.

9. Dante, *Purgatorio* 11. 94–95.

10. Hans Sedlmayr, *Art in Crisis* (London, 1957), pp. 10–11.

### VI. *Working with What Is There*

1. George Henderson, *Chartres* (Harmondsworth, England, 1968), p. 81.

2. Ibid., p. 95. There has long been a controversy over whether the cathedral was rebuilt from east to west or west to east. According to Jan van der Meulen, "Recent Literature on the Chronology of Chartres Cathedral," *Art Bulletin* (June 1967), the nave was begun before but completed after the east end of the cathedral.

3. The other subjects in the window are the Threefold Temptation and the Marriage at Cana.

4. See Robert Sowers, "A Hypothesis about the West Front of Chartres," *Art Bulletin* (December 1982), p. 622. In the diagram accompanying that analysis, reproduced here (Fig. 67), the center window is shown two tiers of medallions, or approximately seven feet, taller than it actually is.

5. See John Neff, "Matisse and Decoration: An Introduction," *Arts Magazine* (May 1975), p. 59.

6. *Matisse On Art*, ed. Jack D. Flam (New York, 1978), p. 68.

7. Ibid., p. 69, in a second letter amplifying on the difference between easel painting and architectural painting.

8. See especially Alfred H. Barr, Jr., *Matisse: His Art and His Public* (New York, 1951); John Jacobus, *Henri Matisse* (New York, 1983); and John Russell, *The World of Matisse* (New York, 1969).

9. Quoted in Raymond Escolier, *Matisse: A Portrait of the Artist and the Man* (New York, 1960), p. 193.

10. Ibid., p. 113.

11. *Matisse on Art*, p. 139.

12. On March 15, 1989, Richard Serra's *Tilted Arc* was removed, thus restoring Federal Plaza to its original unrelieved ugliness. See Michael Brenson, "The Messy Saga of *Tilted Arc* Is Far from Over," *New York Times*, April 2, 1989.

13. Paul Goldberger, *The City Observed: New York* (New York, 1979), p. 35.

14. Quoted in Kate Linker, "Michael Singer: A Position In, and On, Nature," in *Art in the Land: A Critical Anthology of Environmental Art*, ed. Alan Sonfist (New York, 1983), p. 188.

15. See Sonfist, *Art in the Land*, pp. 11, 38, 63, 247.

16. Elizabeth C. Baker, "Artworks on the Land," in Sonfist, *Art in the Land*, pp. 75–79.

17. Quoted in Michael Auping, "Earth: A Study in Ecological Politics," in Sonfist, *Art in the Land*, p. 95.

18. Ada Louise Huxtable, *Kicked a Building Lately?* (New York, 1976), p. 34.

19. Robert Irwin, *Being and Circumstance: Notes Toward a Conditional Art* (Santa Monica, Calif., 1985), p. 27; Irwin's italics.

*Conclusion*

1. Clement Greenberg, "Modernist Painting," in *The New Art*, ed. Gregory Battcock (New York, 1966), pp. 101–10. Fortunately, Greenberg's critical writing is not bound by the Modernist precepts set forth in this essay. See "Modernist Sculpture, Its Pictorial Past," in his *Art and Culture* (Boston, 1961), pp. 158–63, for example, for an excellent capsule account of the interactions between painting and sculpture from Roman times to the early twentieth century. By contrast, Michael Fried treats the separation of the arts from one another as an absolute yet completely unexamined critical imperative in "Art and Objecthood," in *Aesthetics Today*, ed. Morris Philipson and Paul J. Gudel, rev. ed. (New York, 1980), pp. 214–39.

2. "Percept and Concept—The Abuse of Concepts," in *The Writings of William James*, ed. John J. McDermott (Chicago, 1977), pp. 243–52.

3. The roots of visual expression may well be more closely bound up with tactual than with verbal expression:

> The first stone shaped to fit the hand and seeming magic by virtue of its form, initiates a new era of mental life. That is because the gesture not only may be a movement of complicated and perfect form, but . . . is made in order to realize form. The shaped stone, treated as primitive implements usually are—with concentration on appearance—is not only a tool, it also presents itself at once, through tactual satisfaction and by its visible shape, as an intaglio image of the grasp; this semblance is a translation of touch into sight, bringing the feeling of the human hand to visual expression. Here is "expression" in the conceptual sense, a projection of the feeling, whereby it is conceived, not actually felt, through the appearance of the stone.

Susanne K. Langer, *Mind: An Essay on Human Feeling*, vol. 1 (Baltimore, 1967), p. 143.

4. Reyner Banham, *Guide to Modern Architecture* (London, 1962), p. 20.

# PHOTO CREDITS

# INDEX

*Page numbers for illustrations are in italics.*

Designer:      Robert Sowers
Compositor:    A-R Editions
Text:          11/15 Sabon
Display:       Sabon
Printer:       Malloy Lithographing, Inc.
Binder:        Malloy Lithographing, Inc.